The art of collage

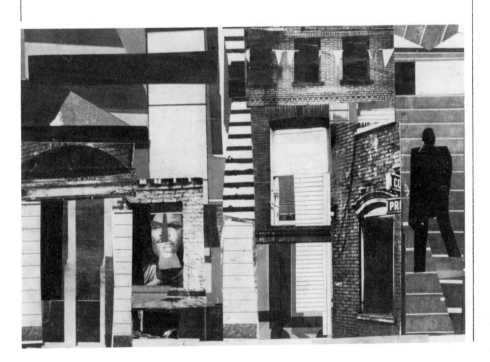

Spring Way, (1964) , by Romare Bearden.

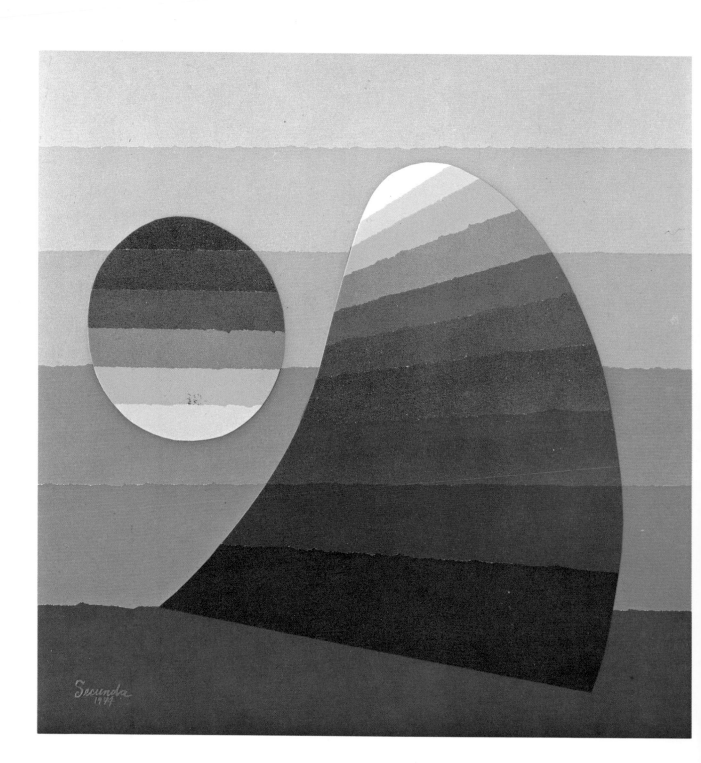

Secunda
1974

Gerald F. Brommer

The art of collage

Davis Publications, Inc.

Worcester, Massachusetts

To George F. Horn, artist, educator, author and friend, who motivates, energizes and encourages at just the right times.

Printed in the United States of America
Library of Congress Catalog Card Number: 77-92192
ISBN: 0-87192-096-4

Composition: Williams Graphic Service
Printing: Worzalla Publishing Co.
Binding: Worzalla Publishing Co.
Type: Helvetica
Graphic Design: Penny Darras-Maxwell

Consulting Editors: George F. Horn, Sarita R. Rainey

Front cover and frontispiece:
Island, (1974), (76 x 81 cm.), by Arthur Secunda.

Collection of Haddad Fine Arts, Anaheim, California.

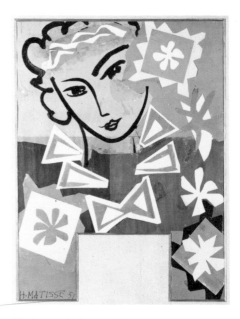

Madame de Pompadour, (1951), (89 x 64 cm.), by Henri Matisse.

Los Angeles County Museum of Art, gift of Mr. and Mrs. Sidney Brody.

10 9 8 7 6 5 4 3 2 1

Contents

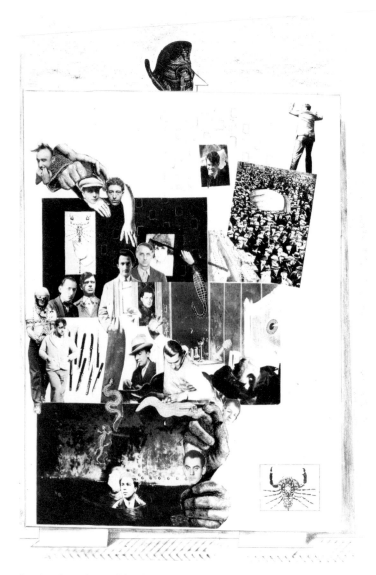

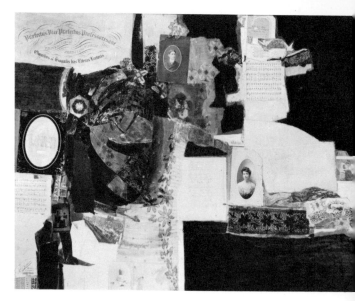

*Loplop Introduces Members of the
Surrealist Group,* (1931), (51 x 34 cm.),
by Max Ernst.

Collection of The Museum of Modern Art, New York.

Untitled Collage, 46 x 61 cm.,
Lutheran High School.

Oval Lover No. 123, by Maury Haseltine.

Collection of Salt Lake Art Center, Salt Lake City, Utah.

Introduction

The scope of this book, from the mystical expressions of Max Ernst to the searching experiments of today's high school students, has expanded greatly since I started working on it several years ago. The collage artists of America have caused this expansion, because their responses to my appeal for help was so tremendous. Over eighty artists from across the country sent more than one thousand examples of their work to me for use in this book. This generous sharing of talent is a beautiful thing, because, through it, young artists around the world can see what a wide range of expression collage has to offer. I could not use all the photographs that were sent, but I tried to keep those that would help the readers understand the text and provide stimulation for experimentation.

The book is written for three audiences, which is a difficult task to start. *Students* will find a fantastic array of visual expression that will be wonderfully exciting. It can also be overwhelming! However, there are also many examples of student work (from junior high schools and high schools) that will illustrate some basic approaches. The professional work and examples from museums will be inspirational and provide an historical context. It can provide motivation for students to seek new and personal expressions.

Teachers will find a wealth of activities that can be used as is, or modified to fit any classroom situation. There are visual examples that cover almost all phases of collage activity. Many of the works are from museums and the personal collections of the artists themselves. Sections of the book deal in detail with materials and techniques that should prove very helpful in the classroom. Certainly, the entire contents cannot be used in a semester, or even a year, but ideas generated from the work shown can provide vital projects for many young art students.

Artists will find stimulation and encouragement for individual experimentation in the work of their peers. Many of the finest collagists in America have shared their work (and therefore their ideas) with you on these pages. What you do with their generosity is really up to you.

This book is intended to generate ideas. As I look through the stack of photographs that will be sent to the publisher, I am overwhelmed by the variety of methods and techniques used by the artists. I hope that, in some way, their personal visual language and artistic enthusiasm will be communicated to you as it has been to me.

GFB / Los Angeles / 1977

Collage — a recent medium

1

How it started

To trace the history of collage as a folk art, you have to look back almost eight hundred years ago to the early Japanese artists, who used pasted paper backgrounds for their descriptive poetry. People in succeeding generations have pasted remembrances, valentines, cloth, lace, feathers and papers, on various backgrounds, such as boards, furniture or lampshades. But the technique of pasting paper did not enter the realm of fine art until Pablo Picasso and Georges Braque, two artists working in France in 1912, began embellishing their canvases with glued materials.

Oilcloth and wallpaper, containing patterns of simulated chair caning and wood textures, were the first items that the two artists adhered to their work. They used these patterns instead of painting areas or shapes of caning and woodgrain on their canvases. As the technique spread in use and application, these first items were followed by bits of newspapers and painted papers. At first, actual newspapers were used to show newspapers in a painting. Soon, artists using collage saw headlines and type simply as textural materials to enhance their work.

One of Picasso's early collage attempts. Note the charcoal lines that are independent of the collaged papers and the ink that he used for the darkest shape beside the face. *Man with a Hat,* Pablo Picasso, (1912, December) (63 x 48 cm.).

The Museum of Modern Art, New York.

A collage using printed book pages, newspaper and wallpaper scraps and colored papers. These elements are tied together with charcoal line and shading. *The Table,* Juan Gris, 1914.

Philadelphia Museum of Art. The A. E. Gallatin Collection.

An early collage drawing by Georges Braque, titled *Still Life with Playing Card,* (1912), (30 x 47 cm.), uses shapes of wood-grained wallpaper to provide the texture of the table top. Braque used charcoal in this work, and rarely added paint to his collaged surfaces.

Los Angeles County Museum of Art. The Mr. and Mrs. William Preston Harrison Collection.

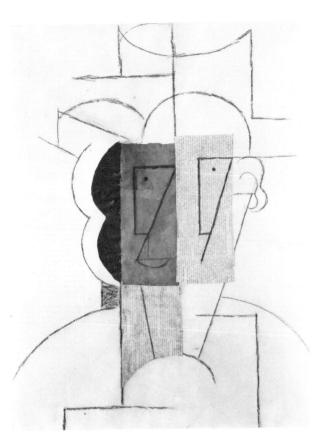

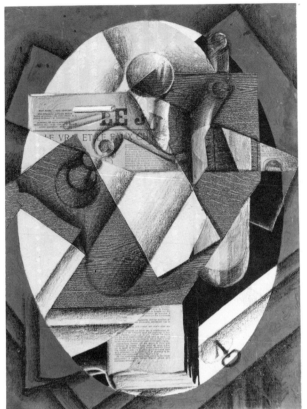

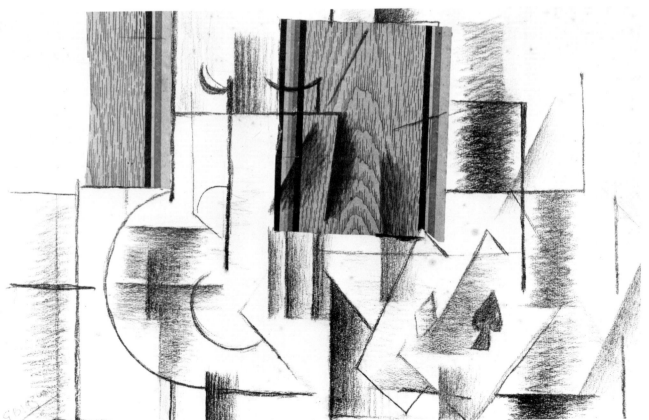

9

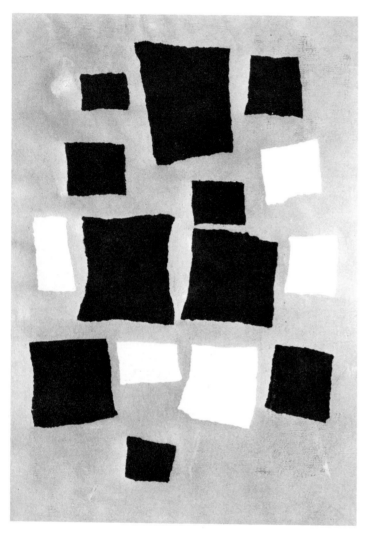

Jean Arp seemingly allowed paper scraps to arrange themselves, as the title indicates. *Collage with Squares Arranged According to the Laws of Chance* (1916–17), (49 x 35 cm.), is made of various torn, colored papers.

The Museum of Modern Art, New York.

How collage developed

As the *Cubists* worked on their canvases by breaking up spaces and shapes, the torn, cut, and folded paper became an important part of much of their experimentation. Pasting or gluing paper to art work was called *papier collé,* the French term for pasted paper.

Both Picasso and Braque, along with the Spanish artist Juan Gris, continued experimenting with other materials, such as textured papers, sand, metal, wood and cloth in both two- and three-dimensional work.

Italian *Futurists,* around the time of World War I, continued and expanded the collage techniques developed in France, as did the German and Russian *Expressionists. Dadaists,* in their *nonsense art,* found collage techniques an exciting new way to express their negative feelings for traditional art forms and ideas.

After a period of reduced collage activity, Kurt Schwitters burst forth in 1919 with an exciting array of personal expressions. Collage and assemblage became his favorite media. The German artist glued and pasted found objects and papers into various arrangements on paper, canvas, and boards.

Surrealists, combining realistic visual images in unnatural combinations, found collage an ideal way to quickly assemble their thoughts. Max Ernst, Jean Arp, Marcel Duchamp and Man Ray used many materials in such combinations to express themselves in their dreamlike ideas.

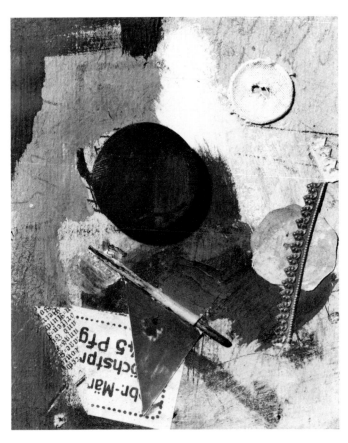

Oil paint and a variety of objects are employed by Kurt Schwitters in his assemblage-painting, *Merzbild 20A*, 1919.

Philadelphia Museum of Art. A. E. Gallatin Collection.

An untitled collage by Jean Dubuffet, (1954), (60 x 37 cm.). The artist used calligraphy over torn printed type to develop a rich textural surface that contrasts strongly with the dark flat area above.

William Rockhill Nelson Gallery of Art, Kansas City.

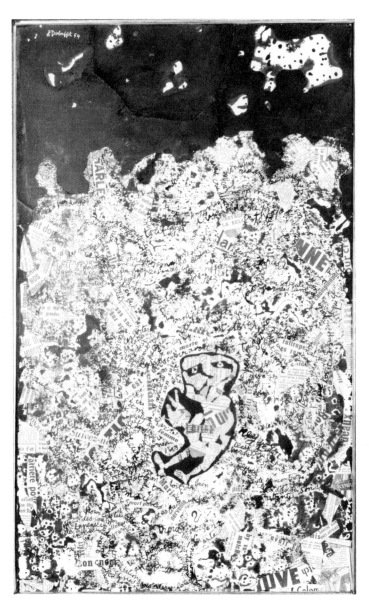

Ben Nicholson created *Painted Relief* (1939), (83 x 114 cm.) by mounting synthetic board, similar to Masonite, on plywood. His carefully controlled shapes and subtly painted surfaces produce a balanced composition of low relief, in which the cast shadow plays an important part.

The Museum of Modern Art, New York. Gift of H. S. Ede and the artist.

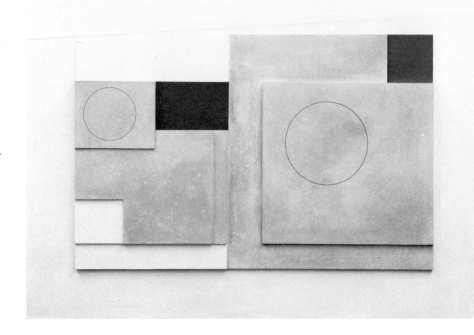

By skillfully manipulating magazine textures and images, Romare Bearden produces collages which make dynamic social statements. *Mysteries* (1967) is a complex arrangement of a wide range of such pictures.

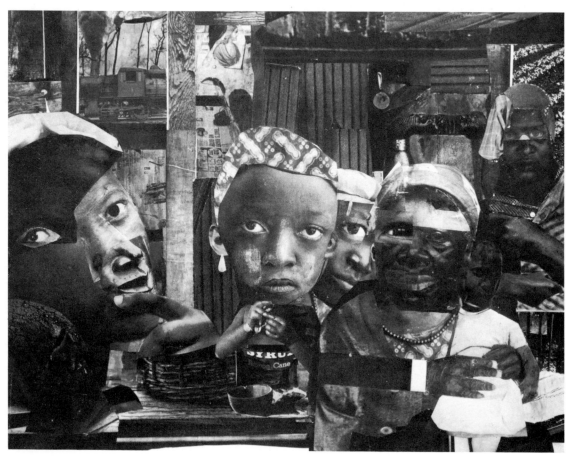

Following 1960 there was another resurgence of interest in collage. The invention of polymer emulsion glues (Elmer's and Wilhold) solved many of the artists' problems of adhering various materials permanently to backings and opened new ways of expression in this medium.

Today, collage has a permanent place in the list of art media, along with painting, drawing, printmaking and sculpture. It is sometimes used alone, or in combination with drawing, painting or printmaking. Found and prepared papers, torn, cut, folded and crumpled, and photographs can be used. New materials, such as acrylic mediums and gels, have expanded the uses and techniques available to artists.

Intricate interlocking shapes and lines are woven together by Margo Hoff to create a richly textured surface. *Three Saints,* (122 x 91 cm.), combines paper collage and acrylics.

Collection of James Michener.

Contemporary directions

Many contemporary inventions have further expanded the concepts begun by Picasso and Braque. The use of photo-copying machines to duplicate paper arrangements has brought startling and instant results which often have a feeling of social protest against the very machinery which produced the art. In the dynamic world of searching artists, collage has a permanent and important place. Almost all artists use some form of collage at some time in their development, to try out new approaches or to make changes in their work.

Collages can be constructed rapidly or may take many hours or days of trial placements and experimentation. They can be carefully and methodically pre-planned and arranged, or they can evolve spontaneously, falling into place by happy coincidence.

However you work with collage, you will feel the satisfaction of instant creation, as the image is formed.

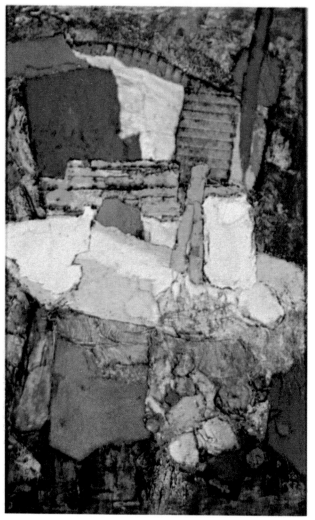

Japanese rice papers stained with a batik technique form the background for *Tumble Weed,* (56 x 71 cm.). James Varner Parker then uses acrylic paint to place the stylized plant over the collage in a carefully controlled design.

The warm and intense colors of Ida Ozonoff's collage seem to stand forward from a neutral background. She includes rice paper, cardboard and corrugated board in creating *Carnival I* (1966), (51 x 30 cm.).

Collection of Mr. and Mrs. Bjorn Bjornson.

14

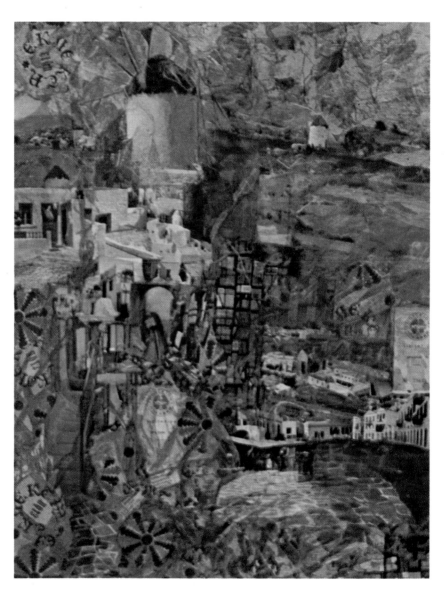

...und, printed images and acrylic paint
...e combined by Gordon Wagner to
...eate the delightful fantasy *Mini Ha-Ha*
...973), (29 x 21.5 cm.).

...llection of Dr. and Mrs. Harold Brown.

...hel Margolies uses fragments of reality,
...ch as tickets, maps, travel folders and
...ttering, to add a feeling of authenticity to
...r work. In *Mykonos* (named after a small
...eek island), she creates unity by adding
...erlays of color.

Large, flat shapes surrounded by heavy
lines produce a collage-like feeling in
Arshile Gorky's oil on canvas, *Still Life*
(1936/37), (89 x 71 cm.).

Los Angeles County Museum of Art. Gift of Mr. and
Mrs. Hans Burkhardt.

Bright colors and flat areas of paint, com-
bined with a hard edge technique, cause
Stuart Davis' oil paintings to look like
collages. In *Something on the 8 Ball*
(1953–54), the artist uses calligraphic
shapes in conjunction with geometric
shapes to create an exciting tension.

Philadelphia Museum of Art. Beatrice Pastorious
Turner Fund.

Some influences of collage

Collage artists, by incorporating actual objects, textures, fabrics and printed papers in their work, were mixing reality with illusion. Actual lettering and headlines from newspapers replaced simulated type in paintings. Real fabrics took the place of painted illusions.

Gradually, collage artists began to simulate even this new reality. Instead of gluing wallpaper to the canvas, they painted a shape to *look like* wallpaper glued to the canvas. Viewers were often confused because of the ambiguous quality of such work. The broken design techniques that the use of collage techniques helped to develop were instrumental in the development of paintings that had a strong collage-like feeling.

Succeeding generations of artists have been influenced by collage techniques, and many artists have continued to create paintings that have a direct relationship to the torn and cut shapes of collaged surfaces.

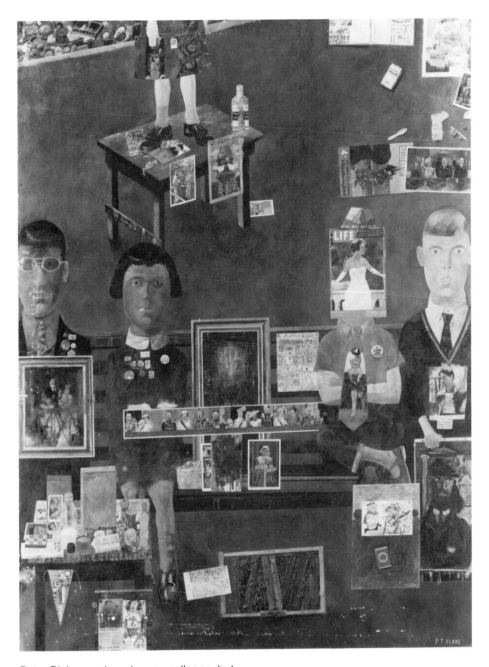

Peter Blake produced many collages, but *On the Balcony*, (1955) is not one of them. This large oil painting (122 x 91 cm.) is made up of smaller parts that *seem* to be glued to the surface. The artist is toying with your visual senses and wants you to be amused.

The Tate Gallery, London.

17

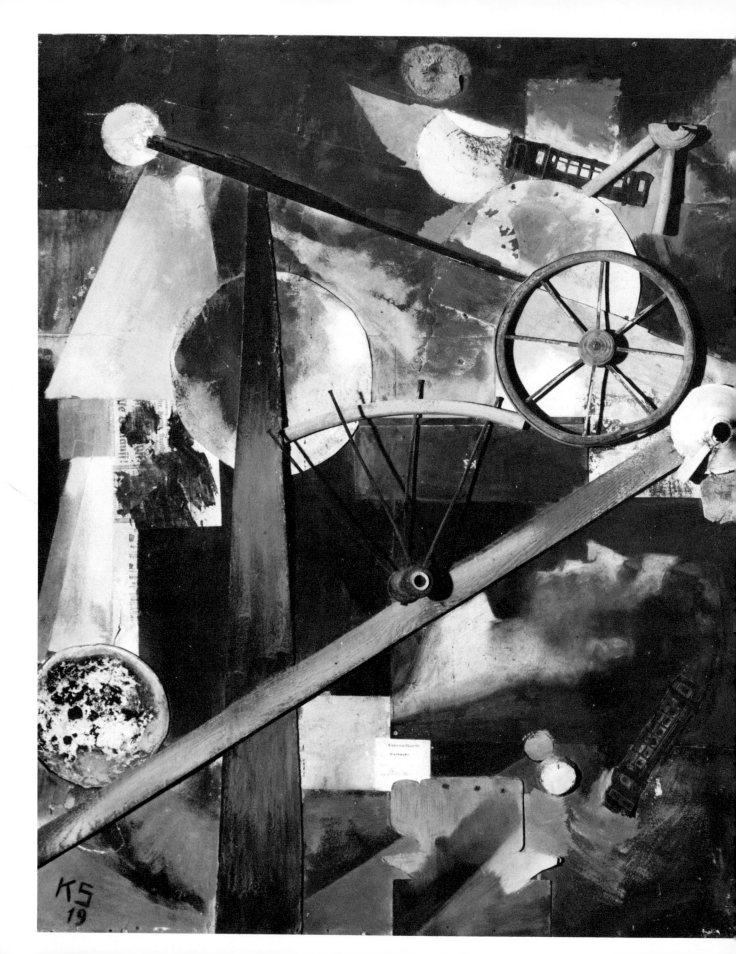

Assemblage – the natural outgrowth of collage

Before exploring the techniques of using paper in collage, it might be interesting to note a few directions in which these techniques might lead.

It was natural for cloth, leaves and feathers to find their way into collages. Seeds, sand, pods, wood, plastic, wire, screen and metal soon followed. Two-dimensional panels became relief sculptures and, finally, fully developed three-dimensional assemblages. Anything natural or manufactured became the raw material for these works.

A glance through the catalogue of an assemblage exhibit would reveal such materials as mirrors, stuffed birds or animals, boxing gloves, clock parts, bottles, steel springs, buttons, automobile bumpers or crumpled car bodies, bicycle parts, wooden toys, and other such "non-art" items. While collage artists were concerned with how one texture or color led into another, creators of assemblages put objects together with a feeling of random arrangement. Textures, colors and forms are assembled with the principles of design (balance, movement, rhythm, contrast, emphasis, unity and pattern) holding them together visually.

Sometimes paint is added to a work, but in others, the found forms are left unchanged. Many times the objects are related to form a theme, such as the seacoast or sports. In others there is no relationship at all, except that they share space in the same work.

Technology has allowed artists to use electricity in assemblages so that lights and/or sound can be added. Artists interested in *kinetic art,* moving sculpture, can program their constructions to swirl, jump, light up, turn around and quiet down again. Computers, neon lights, electric motors and sound tapes are incorporated into some assemblages. And it all began when scraps of oilcloth and wallpaper were added to canvases in 1912.

Kurt Schwitters has combined found objects, wood and metal, with paper and paint to create his assemblages. *Construction for Noble Ladies* (1919), (103 x 84 cm.).

Los Angeles County Museum of Art.

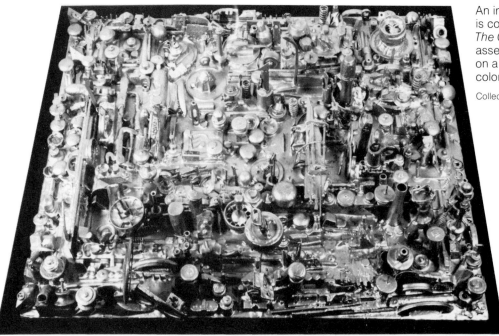

An incredible assortment of found objects is collected by Arthur Secunda to create *The City I* (1960–63), (26 x 69 x 84 cm.). Th assemblage is designed to be placed flat on a table. It has been sprayed a single color to create a feeling of unity.

Collection of Hans Floderus, Sweden.

Louise Nevelson collects huge quantities of found wooden forms and assembles them in boxed compartments. *Sky Cathedral,* (1958), (3.6 x 3.26 meters x 46 cm.), is a monumental wood assemblage painted black.

The Museum of Modern Art, New York. Gift of Mr. and Mrs. Ben Mildwoff. Photograph by Eric Pollitzer.

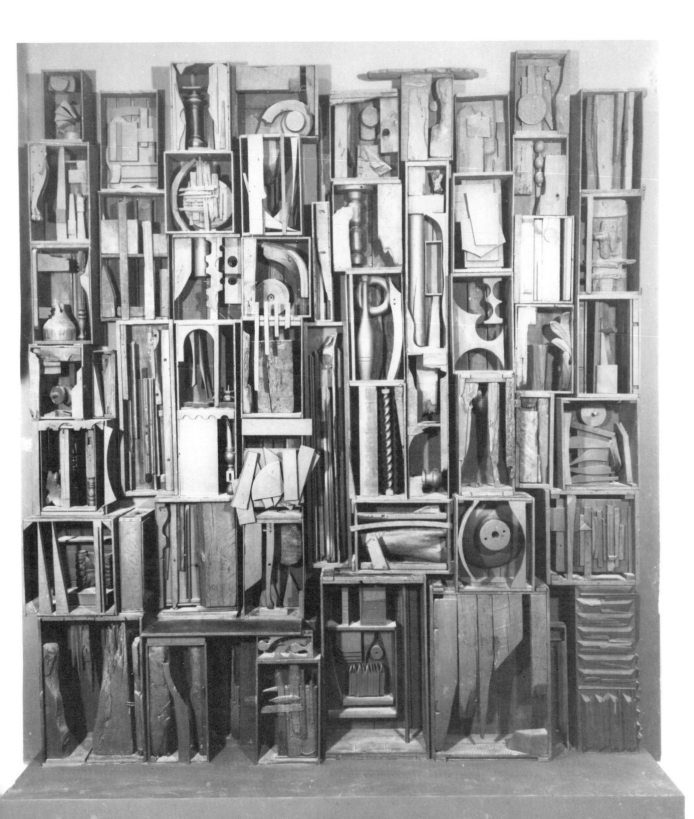

Commercially colored papers from brochures and announcements are cut and torn for use in *Affirmation*, (1972), (39 x 48 cm.), by Kathleen Zimmerman. Strong and simple shapes are overlapped in an apparently casual way, but careful study reveals attention to all the art elements and principles.

Colored tissue paper and several opaque papers are combined with paint in Helen van Buren's collage, *Some Fruit*, (102 x 7 cm.). Wrinkled papers cause ridges which establish a textural quality to the work.

An emphasis on paper collages

During the time when assemblage artists were experimenting with their visual constructions, collage artists were continuing to develop their techniques. From the initial Cubist influences, paper collages have developed in many directions. Extremes of realism and abstraction were pursued, as well as many areas in between.

The variety of available papers increased with time and technology, and an array of Oriental rice papers was introduced to Western artists. Metallic foils and commercially-colored papers enabled the collage artist to work with a vast range of colors and textures.

Photography and refined printing techniques, in both black and white and in color, presented the artists with opportunities to incorporate realistic images or photographic textures in their work. Papers could be torn to leave organic edges, or cut to produce sharp-edged geometric shapes. They could be folded, crumpled, scored, soaked, shredded, or perforated. Improved adhesives allowed artists to work more quickly and develop more permanent collages.

Color was added with oils, watercolors, tempera, casein and, more recently, acrylic paints. Drawing was done on collages with pencil, charcoal, crayon and pen and ink. These colors and lines were applied under the collage material, over the top of the pasted surfaces or a combination of both.

All of these possibilities and techniques have provided the substance and the background for us today. Personal expression is limited only by our imagination.

Collagraph proofs (prints made by the artist) are cut and used as raw materials for a new visual expression by Stanley E. Lea. *The Tree of Life, Bursting into the Universe with a Heart* (1975), (102 x 76 cm.).

Found papers are crumpled, wrinkled, torn, scorched, and finally adhered to a backing in Larry Johnson's *Ancient Battlefield* (1958), (113 x 94 cm.). Some areas are painted, others are left unpainted.

William Rockhill Nelson Gallery of Art, Kansas City.

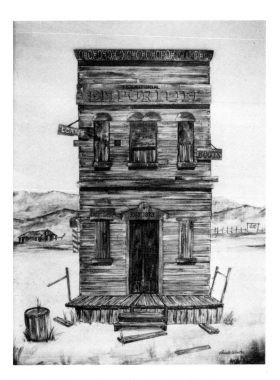

Lightweight cardboard is glued to illustration board to produce a low relief surface in *Emporium,* (61 x 46 cm.), by Chuck Winter. Many textures are real, others are simulated by using casein paint.

Found papers are employed by Nicholas Follansbee in this untitled 19 x 12 cm. collage. Postage stamps, envelope cancellations, old book pages, covers, and end sheets are used. His paper palette includes old postcards with calligraphy, printed sheets, lettering, and stacks of papers that have fascinating colors, textures or stains. He often adds natural objects, such as leaves or flowers.

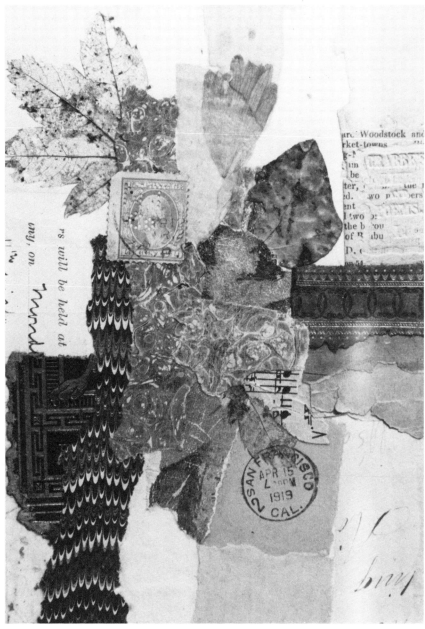

A blending of materials is carried out by James Varner Parker in *Pueblo Motif No. III,* (61 x 76 cm.). Three panels have gold leaf with tissue paper overlay. The moon is silver leaf. The branches and berries are painted with acrylics. The Indian pot is painted on paper and glued to the first panel.

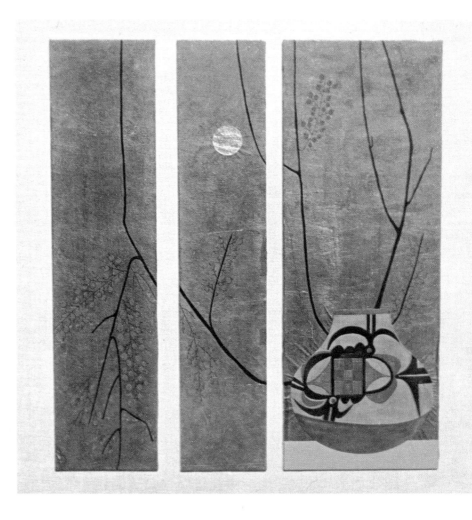

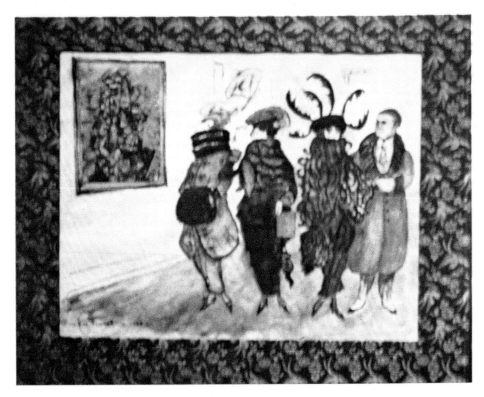

A photo reproduction of a group of fash-
ionable Parisiennes (collaged) is viewing a
Georges Braque cubist collage, a repro-
duction of which is collaged onto the paint-
ing. In this collage by E. M. Plunkett, some
painted areas complete the work, titled
Salon d' Autumn, 1913, (1968), (27 x 46
cm.).

Collection of Robert Rosenblum.

The printed color and textures from
magazines are used by a student to
design this collage (46 x 30 cm.).

Lutheran High School.

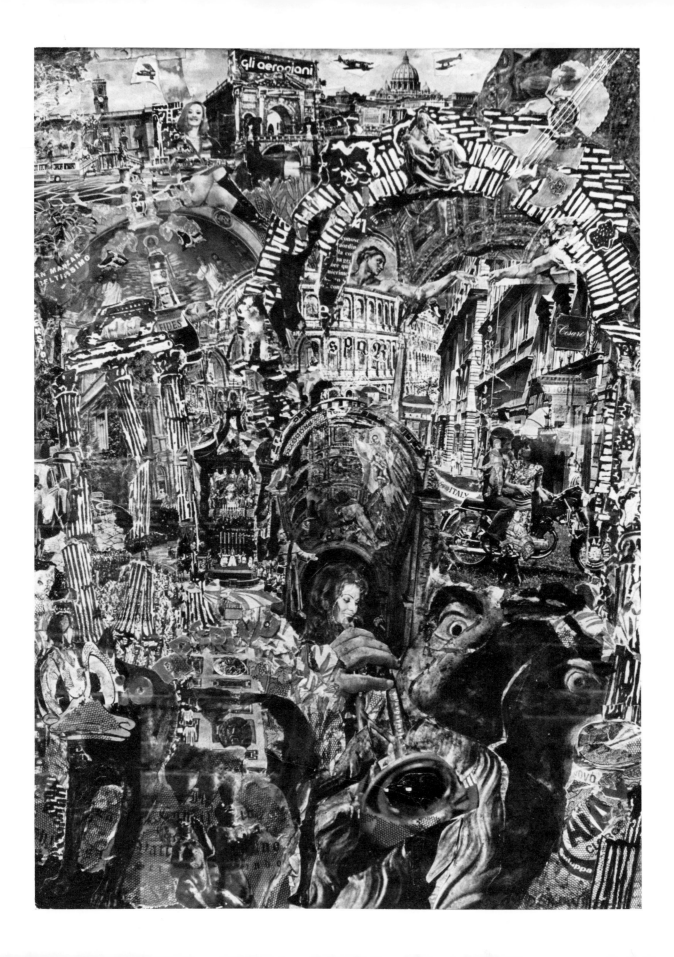

Techniques and terms related to collage

Not only did artists glue paper to canvas or other backings, but, once this was done, they may have torn pieces off again. This produced a surface much like that of an old and much used billboard. The process of tearing back layers of paper is called *décollage*.

There are several other techniques of working with paper. They are:
Stencil — torn or cut paper can act as a stencil for spray painting or working with crayons. The resulting images can be used with real shapes or objects to produce interesting combinations.
Transfer collage — transferring the inked image from a magazine illustration to a new surface. Various materials can be used in the process. The resulting images can be used alone or in combination with straight collage, drawing or painting.
Collagraph or *combine print* — a print made from a collage of paper or other items, usually in low relief.
Photomontage — a collage of cut and pasted photographic material.

There are many methods of preparing the papers you use. These will be discussed later in the book.

Two-dimensional collages are also done in other materials, such as fabrics, metal foils, threads and natural materials such as leaves and bark. While the emphasis of the book will be on the use of paper in collage, you can get many ideas by studying collages created with other materials.

The Eternal City (1975), (61 x 46 cm.), a photomontage by Shirley Moskowitz, is carefully composed of dozens of visual images of Rome. It is arranged to have a sense of depth, with smaller objects in the distance at the top and larger items at the bottom. The artist has used bits of old blockprints, string, net, and acrylic paint to finish the collage.

The darkest value areas in Stephen Seemayer's untitled work are decollaged. The surfaces of these areas are cut and peeled off, then carefully shaded with ash. The wispy, gray areas are created when flame scorches the paper, a technique called *fumage*. The artist calls his technique flame painting.

Courtesy of Orlando Gallery, Encino, California.

The collages of Banerjee are delicately simple in their arrangement, but complex in materials. *Torn Tree #2* (1975), (172 x 97 cm.), is composed of Origami, blueprint paper, fumage, horse hair, nylon string, paper, oil stain, lead and colored pencils, and latex paint on canvas.

Stick pins, fibers, and several papers are used by E. S. Pearlman to create *Time in Rock* (81 x 51 cm.). The artist uses everyday materials, placed in delicate balance, to let us look at mundane things in our environment in an exciting, new arrangement.

Found collages

Once you have studied some of the work of collage artists, you become aware of similar textures, shapes and compositions in your own environment or travels. Often, such images trigger the ideas for pasted collages that can be created in a studio or classroom.

Billboards that have weathered, bulletin boards that are crammed with notices, type and pictures, envelopes pasted with stamps and directions, kiosks showing splashes of color, lettering and texture are examples of places to look for found collages. Your own room, garage or neighborhood might provide you with other examples. If you isolate them and photograph them, you will be surprised at the collage-like feeling they have.

Artists and photographers can find other subjects that have the quality of collage. Some scenes or locations often provide the assembled or broken-up feeling of a collage. If you have your eyes open and your senses aware, you will find that some of these ideas can become subjects for collages.

Contemporary collagist and printmaker Richard Wiegmann photographed these décollaged surfaces from old billboards in the subway stations of Paris. His careful selection of areas with strong design qualities shows what a trained eye can see in our urban environment.

Double exposures, made by several over-
lapping photographic images in the cam-
era or the darkroom, have the same visual
impact as a photomontage or collage.

Empty Oil Cans, a photograph taken in India by P. Mansaram, creates the feeling of collage. Look about you for similar views that suggest the sense of collage.

A pasted up envelope from Arthur Secunda contained photographs of the artist's work for this book.

Materials and techniques

2

One of the interesting aspects of working with collage is the availability of materials. Almost anything can be used to create shapes, colors, lines or textures. The variety of materials is almost endless. They can be bought or found in your garage. They can be manufactured or home-made — and most of them are reasonable in cost. Artists may gather specific materials for a particular collage, or might work with the same materials in varying techniques. Still others have large bins in which all kinds of papers and found objects are kept, until the right place for each one is evident. This chapter will give you an idea of the wide range of useful collage materials. But, effective collages can also be made with only a few pieces of paper.

Materials usually needed for paper collages include a mounting surface, adhesives, papers, brushes and maybe some paint, pencils or inks.

Grounds

The mounting surface on which the gluing is done is called a *ground*. A wide variety of boards and papers might be used as the ground. Because the gluing of papers can easily cause warping and buckling, the ground should be substantial enough to resist such action.

Scraps of untempered *hardboard* (Masonite, Weldwood, etc.) make excellent surfaces. They can be obtained from lumberyards in various thicknesses. Avoid the tempered surfaces, since they have an oiled surface which makes successful gluing difficult. Use the smooth side for easiest adhering.

Cardboards of various types, the heavier weights being desirable, can be used. Illustration board (if you want a white background), poster board, mat board, chip board (the thicker, the better), Upson board and bristol board are all excellent and will resist warping when papers are glued to them. Lighter weight sheets can be mounted on heavier cardboard, hardboard, or plywood for more substantial grounds. In the classroom, a medium or heavy chip board is the ideal ground. A rule of thumb: the heavier the collage, the thicker the ground.

Stretched canvas and canvas boards are also usable, and are especially good if oil or acrylic paints are to be used with the collage.

Experiment with any flat surface to see if it will retain its flatness when materials are glued to it. Try using foam core boards, watercolor papers and boards or heavy papers to see which ground best suits your particular techniques.

Ruth Gewalt uses bark, roofing paper, and heavy sandpaper in her collage, *Rancho Twilight* (76 x 51 cm.). Because of the weight of the materials and the amount of glue needed, a heavy, white illustration board is used as the ground.

Alexander Nepote uses many layers of heavy papers to develop a richly textured surface on which he paints wtih acrylics and watercolors. Because of the heavy work that the ground supports, he used pressed board (Masonite) as his backing material.

Collection of Lytton Savings and Loan Association.

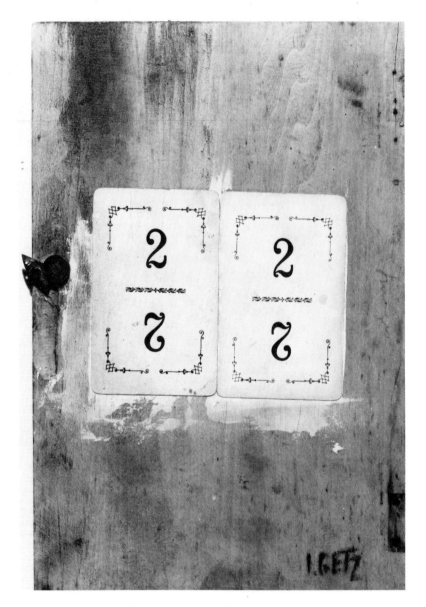

Wood is the ground for *The Game II* (1957), (24 x 16 cm.), a collage by Ilse Getz. The texture of the wood surface becomes an important part of the completed work.

Collection of Gibson Danes.

Cardboard squares (30 x 30 cm.) are collaged on both sides, then assembled into a cube. Cut out shapes on several sides allow the viewer to see the interior collaged surfaces.

Lutheran High School.

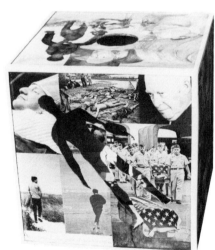

Adhesives

The variety of adhesives is almost as great as the variety of grounds and papers. Try several to help you determine which works best for your techniques and materials.

Acrylic emulsions are available in several forms: emulsions (thin), gels (thick), and modeling pastes (thickest). They are available in matte and glossy finishes. Gels and modeling pastes are thick and strong and more reliable when working with heavier objects, such as sand, gravel or rocks. The thinner emulsions work well with papers and are white in the jars, but dry to a clear, hard finish. Thicker emulsions can be thinned with water, are waterproof when dry, and can be used as a finish coat over the completed collage. Gels and modeling pastes can be used as adhesives, but they can also be textured to produce additional surface interest.

White glues are similar in their application to acrylic emulsions, although a bit thicker. They come in a variety of bottles and tubes and under several trade names (Wilhold, Elmers, Sobo). They can be thinned with water, if too thick and heavy, and are easily used in the classroom. Brushes and pans can be cleaned with warm water.

Rubber cement and *library paste* are usable in the classroom, but are not permanent. Although they afford some convenience in their use, both tend to leave spots and discoloration on certain papers.

Wheat paste and *wallpaper paste* may be used (follow mixing directions) and can be made more effective by adding a small amount of white glue to the mixture.

Clear lacquer (the thicker the better) is an excellent adhesive for tissue paper, turning the colors into brilliantly transparent hues. The lacquer (use the type with heavy solids) is not a true adhesive, and must be put under and over the tissue paper in a laminating technique. Some *shellacs* will work in the same way.

Several types of rice paper are adhered
with white glue to the surface of a heavy
watercolor paper. The dry surface is then
painted with transparent watercolor to pro-
duce a richly colored and textured collage.
Hazy Bright, a work by the author, 76 cen-
timeters.

Epoxy glues are very strong and are most useful with unmanageable or non-absorbent materials. Such strength is not required when working with papers.

There are a number of other adhesives in liquid, powder, stick, paste or spray form that are excellent in certain situations. Try several adhesives to determine ease of use and satisfactory end product.

Brushes and Other Tools

The tools needed for paper collage are simple and inexpensive and are probably already in your studio or classroom.

Brushes, round or flat, are the basic tool for applying adhesives. They must be sturdy enough to push the glue into the required areas. Bristle brushes work best and should be well made so they do not shed while working. The size of the brush depends on the size of the area on which the collage materials are being applied, but one-half to one inch brushes work well. Keep brushes clean or in water when not in use. While using, keep them in water. If lacquers or shellacs are used, be sure to have the correct solvents for brush cleaning.

Containers for glue should hold enough for the job at hand. Old saucers, plastic cups, small jars, or even paper cups are useful. Do not dip brushes back into the original jars because some papers, especially tissue papers, bleed and the glue will become colored.

Apply the glue to the mounting surface (ground) or to the back of the paper to be adhered to the surface. If the papers are very thick or unmanageable, you may have to apply glue to both surfaces to insure a good bond. Put the paper in place and smoothen it with your fingers. A stiff brush or rubber brayer may be used, but fingers are excellent. Start the pressure from the center of the added paper and work toward the edges to prevent trapping air in small bubbles. If bubbles do appear, they may be popped with a pin or cut with a razor blade.

Papers can be kept relatively clean by using the "pastebook" idea. The shape to be pasted is placed, face down, on a clean page of an old magazine. Paste is applied to the edges of the cut shape, in an outward motion, then the shape is lifted and adhered to the mounting sheet. The page of the magazine is then turned, so that the next page provides a clean, paste-free surface for the next paper shape.

If neatness is desired, glue should be applied to the paper shapes that are to be added, then pressed into place. Clean your work area as you go along, because dried glue is difficult to remove from the finished collage. If your work will receive paint, or if the design is loose and free, a few drips or smears will not hurt, and the glue can be applied directly to the ground.

Razor blades and *painting knives* can be used to push or spread glue into place on the mounting surface. Razor blades can also be used to cut papers into desired shapes or to score, cut, or texture the collage surface.

Scissors or razor blades can be used to cut hard-edged shapes. Torn edges do not require such tools, because ripping and tearing with the fingers provide interesting edges.

Pins can be used to hold papers in place while the planning and rearranging is going on. If you work on a relatively flat surface, this is not necessary. Tape is often used for the same purpose.

Envelopes, boxes, or some sort of storage space should be available for keeping papers, unless you will finish the collage in a single working period.

If you are going to draw or paint on the collage, the materials you will need for this should also be close at hand.

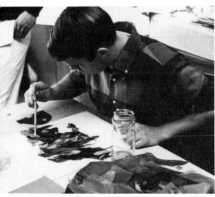

Tissue papers are torn and adhered to illustration board.

Lutheran High School.

Clear lacquer is being used to laminate tissue paper to illustration board.

Various types of brushes and other tools for pushing and spreading adhesives are shown here. Some cutting tools are included in the photograph.

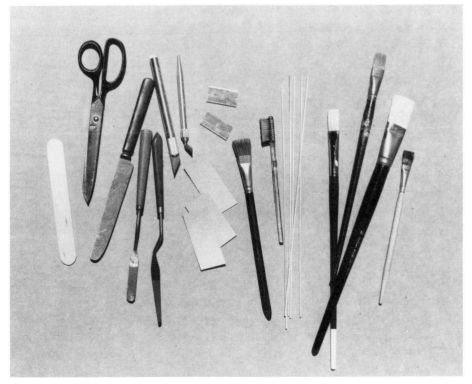

Papers to use

Some collage artists hoard papers like squirrels store nuts. Boxes, drawers, and envelopes around their studios are crammed to overflowing with papers of all kinds, some of which were found, others were purchased. Papers with textures, colors, transparency, lettering, marbling, smoothness, or other qualities might have attracted attention. Collage papers can be *purchased* in art stores, *found* in such places as magazines or advertisements, or *prepared* and/or *altered* by the artists themselves. Most papers are discussed later in the book, but many are previewed here to stimulate your imagination.

Purchased papers

Bond paper, charcoal papers (white and colors), color-coated papers, commercial art papers (color and textures), construction papers (many colors), crepe papers (brightly colored), Japanese papers, metal leaf, novelty papers (textures, glitters, etc.), origami papers, parchment paper, poster board (white and colors), printmaking papers (various weights and textures), rice papers (Oriental) (dozens of types and textures), tissue papers (in many colors), velour paper, watercolor papers (various surfaces and weights).

Some of Ronald Ahlstrom's papers are purchased, others are prepared with acrylic paints. The cut-out shapes are adhered with white glue in this large collage, 122 x 122 cm.

Kuni Strange tears colored papers into small shapes. Then she assembles them into recognizable images to communicate her messages.

Found papers

Bathroom tissue, billboard scraps, brown Kraft paper, brown paper bags (new and soiled), catalogue pages (color and black and white), contact papers (many colors and types), corrugated cardboard (with and without lettering), endpapers from old books, envelopes (new and used), greeting cards of all types, gummed labels and tapes, labels, magazine pages (type, color, black and white, photographs, advertisements, etc.), newspaper pages (pictures, comics, advertisements, want ads, weather maps, graphs, etc.), old signs, paper tapes, paper towels, photographs, postage stamps (new or used), postcards (old or new, color or black and white), posters, postmarked papers and envelopes, shopping bags, stick down type, tar paper, tickets and stubs, transfers, typewritten paper, wallpaper (new, used, and from sample books), wrapping paper (new and used).

Newspaper pages provide various type sizes and styles in Ann Brigadier's collage. Tissue papers provide the colored, wash-like areas.

From *Collage: A Complete Guide for Artists*, Watson-Guptill, by permission.

Prepared and altered papers

Coloring can be added to papers before they are glued to the ground. Materials for coloring include: acrylic paint, casein paint, crayon, crayon resist, fabric dyes, felt pens and markers, gouache, inks, poster paint, spray paints, stenciling, tempera, watercolor.

Texturing and coloring of papers, prior to adhering, can be done with: addition of sand, brayers, brushes of various types, charcoal, crayon, felt pens, fiber pens, pencils, spattering, sponges, spray cans.

Papers can receive impressions from an inked surface, using any of the printmaking techniques: channel prints, collographs, cut potatoes, etchings, found objects, intaglio prints of any type, linoleum cuts, monoprints, rubbings, silk screenprints, woodcuts.

Papers, either found or purchased, can be altered to create new and exciting effects. These can be glued to the ground alone or in combinations with other papers. Fascinating effects can be achieved by: batiking, bleaching, burning, charring, composting, crinkling, making paper by hand, marbling, sanding, scorching, scoring, scraping, smoking, soaking, staining, tearing, wetting and rubbing.

Various tints and shades of a single color were painted on sheets of paper, then cut to use as the palette for this collage. The heavy dark line was painted around the positive shapes to unify the composition.

Lutheran High School.

Ruth Gewalt smoke-stained some of these papers by passing them over a flame. She then combined their delicate quality with the heavy coarseness of tar paper. *New Mexico* (61 x 91cm.) is a collage on canvas.

Various papers, composted until they were partially deteriorated, are combined by Pauline Eaton in a three-dimensional study, *High Horizons* (56 x 41 cm.).

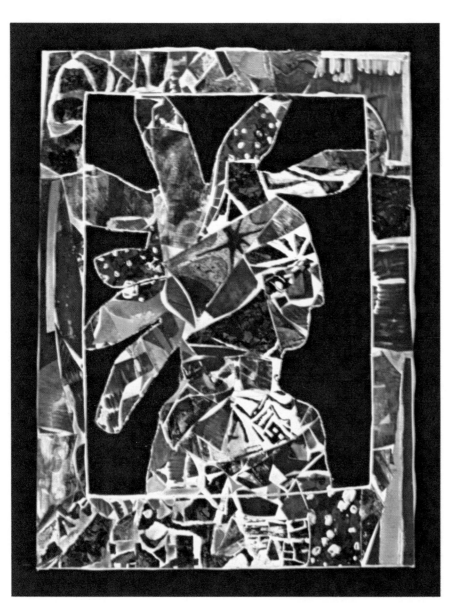

Recycled materials

Some artists need not look very far for their collage materials, finding them right in their studios. Old paintings, prints, drawings, or other collages that are no longer satisfying to the artists can be torn or cut into smaller pieces and used as fresh material in new collages.

Si Lewen's work on this page was started as a watercolor prior to 1955. It was then cut and torn up in 1955 and used in a collage of a figure with an umbrella. Finally it was recycled again in 1975 into its present form, *Choctaw*. There may be further rejuvenation in the years to come.

Old prints, etchings, woodcuts, linoleum cuts, serigraphs, collagraphs, lithographs or monoprints can furnish color and texture for your collages. Instead of discarding proofs or damaged prints, store them for use as potential collage material.

The same holds true of watercolor, acrylic, tempera, or oil paintings. Instead of throwing them away, consider parts of them for collage possibilities. They can be kept as is or cut and torn into smaller pieces and stored in large envelopes to use later.

Your collage may be made entirely of these recycled pieces or it may become a complex arrangement of such pieces combined with many other papers. In any case, your own previous work becomes the found objects for exciting new collage statements.

Si Lewen's *Choctaw* (1975) is the result of several generations of art work. The artist likes his work to have a sense of previous existence and continuing transformation.

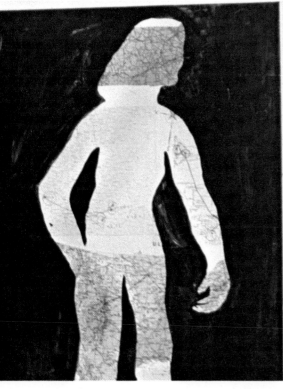

Found paper materials

You are literally surrounded by collage materials. Any used paper product can be given a second life in one of your collages.

The first source that comes to mind is probably the stack of *magazines* that you were going to throw away. But think also of the brilliant colors, textures and patterns on *gift wrapping papers*. *Greeting cards* by the millions are thrown away yearly, but, if torn or cut, can often provide beautiful lines and shapes that add to collages.

Paper bags, shopping bags, and *large envelopes* are useful as collage material or as the grounds for entire collages. *Maps, brochures, printed advertisements, annual reports,* and other printed matter may be used to provide color and texture.

Paper lace, paper streamers, party favors, and *momentos* can find new life in collage form. All of these found paper materials can be used either as complete shapes or objects, or torn into bits and used for texture and color. All the materials mentioned here are readily available and represent only a few of the many possibilities.

Ann-Marie Kuczun combines acrylic paint with collaged pieces from maps, old drawings, magazine cutouts, and photocopied photographs in her work, *Identity Series: Street Tracings* (61 x 76 cm.).

City (81 x 46 cm.) by Marjorie Stevens is collaged from gift wrapping papers, greeting cards, tissue papers, and several heavier plain papers.

Collection of Barbara Hummell.

45

Jack Selleck finds that cardboard cartons can be used as collage material, which he combines with acrylic paint. The central face in this 76 x 102 centimeter work, *Head Table,* has magazine parts adhered to it.

The author uses papers found on the street (foils, wrappers, cigarette packs, newspapers, sacks) to paste up a store front in Yugoslavia. Watercolor was added to finish the work, *Yugoslavian Street* (38 x 56 cm.)

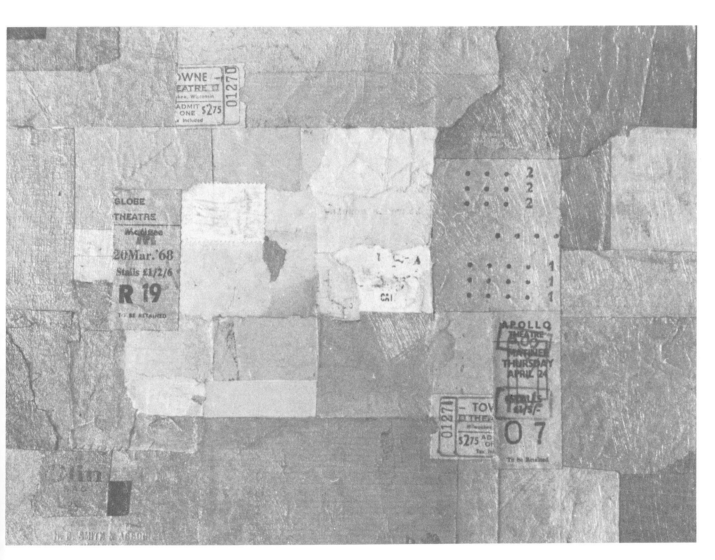

Notice the variety of found papers in Howard B. Anderson's *Odds and Ends Collage*. Tickets, stubs, stamps, receipts, paper bags, and printed and embossed papers have been glued together. Papers are perforated, wrinkled, flat, torn, and cut to provide a variety of edges.

Using fabrics

The textures of many fabrics can add distinctive feeling to paper collages. The torn edges of a fine cotton material or a scrap of coarse burlap can be worked in to yield eye-catching detail. Wool, silk, or synthetic weaves, canvas and cheesecloth have singular characteristics which make them attractive. They provide textural relief in an otherwise flat paper collage. Translucent rice papers, applied over fabrics, often disclose unique patterns.

Entire collages can be made of fabrics, rather than paper. Cloth fragments can be used in their original colors or can be stained, dyed, bleached, or painted as needed to achieve your design. Fabrics can be inked and printed on paper to give the textural effects of fabrics without actually gluing them to the surface.

Fabrics, such as canvas or linen, can also be used as the ground for paper or cloth collages. Some artists prefer working on a primed canvas rather than on the less resilient surfaces of cardboard or hardboard.

Finishes

Paper collages are sometimes displayed with plexiglass or glass coverings. If the suface is delicate or the ground is thin and apt to warp, glass should be used to help flatten and protect the work. If the painted surface is watercolor or poster paint, or if the adhesive is less than permanent, a covering should be used.

Some collage techniques make use of permanent finish materials which do not require a glass covering. Polymer emulsions or acrylic mediums can act as both adhesives and non-porous finishes for collages. They can be used to attain either a matte or gloss finish and several coats will make them extremely durable.

Varnishes or shellacs can be used, but test the finishes on sample papers to make sure that no wrinkling, bleeding or discoloration occurs. If lacquer is used as

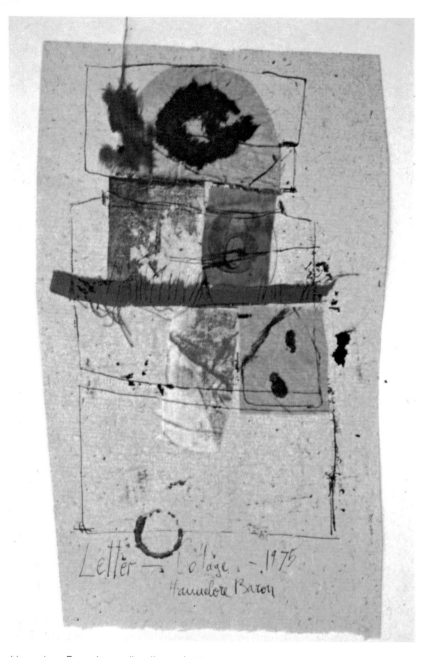

Hannelore Baron's small collage, *Letter*, (19 x 30 cm.), contains many ingredients. Paper and cloth, printed numbers, watercolor, and pen and ink are combined and mounted on handmade East Indian paper.

Courtesy of Kathryn Markel Fine Arts Gallery, New York.

48

a binding agent with tissue paper, several extra coats will seal the surface.

Some artists question the durability of the white glues as a permanent finish because they are soluble in water. If care is taken with the finished work, however, they will preserve collaged surfaces in most cases.

Some spray finishes might be tried. However, first check samples of these special materials to prevent possible disasters.

When in doubt, or to keep the surface flat, use glass or plexiglass to protect the finished collage.

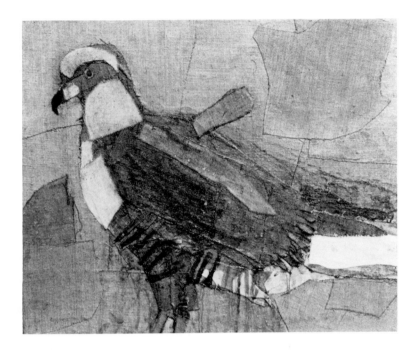

Various types of stained fabric are used by Betty Schabacker to create *Pale Chanting Goshawk* (56 x 46 cm.). You can learn much about design by studying her skillful handling of cloth materials.
Collection of Dr. and Mrs. W. C. Priest.

Jack Ledbetter's untitled collage of soiled and wrinkled brown paper bags and black and white paper is glued, using white glue, to a plywood ground. Several extra coats of glue provide the finish for the work.

A word about design

3

When a person confronts a collage for the first time, the work may seem haphazard and almost thrown together. But, successful collage artists, as any other successful artist, incorporate all the elements of art: line, shape, form, color, value, texture and space.

All artists use and arrange these basic elements in many ways. But for the composition to be successful, collagists should observe certain principles of design in the same manner as that of painters, sculptors, muralists, craftspersons and printmakers. Some artists, however, purposely ignore these principles in order to communicate their ideas more forcefully.

The principles of design are balance, unity, variety, contrast, emphasis, movement, rhythm, pattern and proportion. Since the work of many collage artists is abstract, or might have large areas of abstraction, the artists must concentrate on the elements and principles of design to make their statements successful. The subject matter of a collage might very well be pattern or movement, line or texture, instead of trees or houses, people or sunsets.

Collage artists usually spend much time trying different arrangements of their papers, rearranging lines, shapes and colors, adjusting and positioning, before they finally glue the parts in place. And even then, more adjustments can be made by adding more papers or tearing away others until the composition (the arrangement of parts) feels satisfactory to the artist.

All the art elements are represented in Edward Betts' collage, *Tide Rocks* (48 x 76 cm.). Papers with a variety of size and shape were used to keep the design interesting and vital.

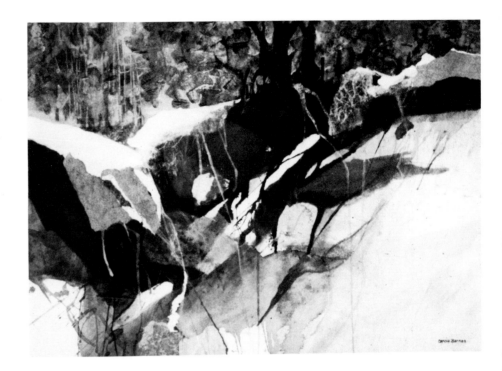

Carole Barnes combines acrylic paint with recycled papers from old paintings and some rice paper in *Run Off* (74 x 89 cm.). Notice the presence of various art elements, but also note the variety of their arrangement.

Pre-painted shapes of related colors are first glued to the ground; then light and dark lines are brushed on, often independent of the shapes. Finally a contrasting color and value is added to provide a center of interest.

Lutheran High School.

A gracefully curving line contrasts with the grid-like lines in Murray Zucker's hard edged collage, *Circular Orbit* (46 x 61 cm.). He cut and adhered commercially silk-screened papers, taking advantage of their flatness and brilliance.

Collection of Eastern States Bankcard Association.

Line

In drawing, line is a most important element of design. In collage, it is not used as much. Line may be implied, where two shapes of different color or value are side by side. The edges of shapes might appear to be line but actual drawn lines might not even appear in most collages.

Long thin shapes (strips) can be cut from paper and used as line in some collage work. String and wire may provide line, or some textured papers (such as rice papers) may have fibers in them that will appear as lines. Some printed papers, type, photographs, or wrapping papers, may have linear qualities that add line to a collage.

Papers can be wrinkled before or in the process of gluing in order to produce a linear feeling. These may be short crinkles or long ridges that are really three-dimensional lines.

Some collages may have actual lines drawn on them with pencil, pen and ink, or brush and paint. Such lines may be added to separate objects, outline shapes, or simply to clarify or enhance the design. If lines are added, they should be made so that they become a part of the collage. If they draw attention to themselves, they will destroy any feeling of unity and harmony in the composition and will perhaps do more harm than good for the design.

If you are thinking of adding a drawn line over the collage, try it first on a clear sheet of acetate or glass to see if it helps. If the collage is just as effective without the line, do not force it onto the work.

Glance through the book to see how many different ways artists have found to use line in their collage work. Several are shown here, but there are many others throughout the book.

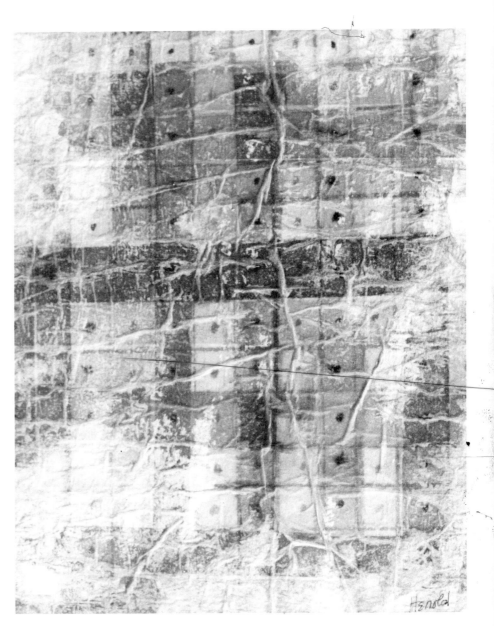

Rick Herold used shellac to adhere layers of colored tissue paper. While the shellac was still wet, he created ridges which appear as raised lines on the papers.

Courtesy of Orlando Gallery, Encino, California.

53

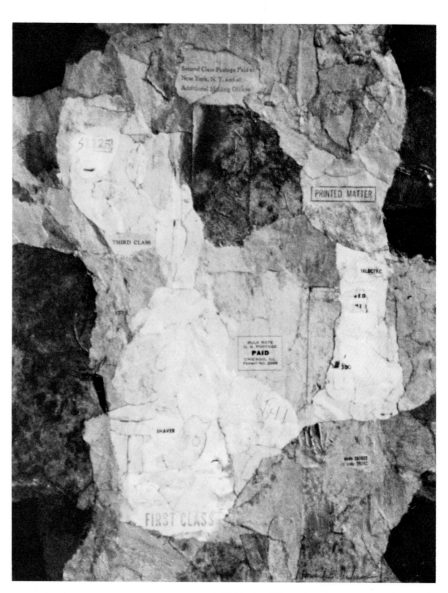

All kinds of found papers are torn into soft edged shapes by Howard Anderson in *No. 2 — Fall '72.* Notice how smaller shapes are combined to create several large shapes; yet, there is much variety in the sizes and subtle colors and values.

Shapes

Shape is the basic element of the collage artist. A work table may be filled with shapes of various colors, sizes and configurations, from which pieces are chosen for a collage. Boxes, bins, or envelopes can hold a wide range of paper shapes which are the raw material for the artist. These shapes can be altered as work progresses, tearing off a corner here or snipping a shape in half there.

Cutting paper shapes with scissors, razor blades or stencil knives will produce sharp, crisp edges that will give the finished collage a hard-edged look. Some artists like this feeling in their work and may use nothing but cut shapes. Other artists may mix cut shapes with torn shapes.

Tearing papers will create more ragged looking edges that will appear to be soft. One shape may seem to blend into another. Some papers tear easily, others are more difficult to control. Thicker papers tear with a different edge than thin sheets. A little experimentation will help you recognize the possibilities these characteristics can have in your work.

Shapes vary in size, and it is often desirable to use a variety of sizes in your work to avoid monotony. However, in some cases, such as developing a mosaic effect, shapes of the same size are often necessary. When very large shapes are glued down, care must be taken to avoid undesirable wrinkles. It is often easier to work with a variety of smaller shapes to build up the desired larger shape.

Transparent or translucent papers will create new shapes as they are overlapped in gluing. Opaque shapes will be changed, also, every time another paper shape is glued to the work.

Look through the book to see how different artists have used different kinds of shapes. As you develop your feel for collage, you will be able to recognize the work of certain collagists by their use of this design element.

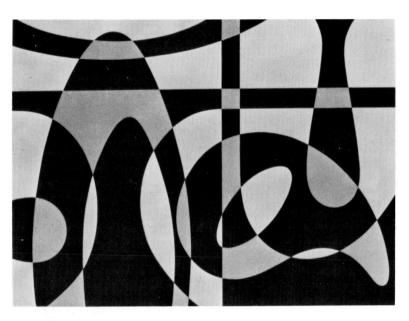

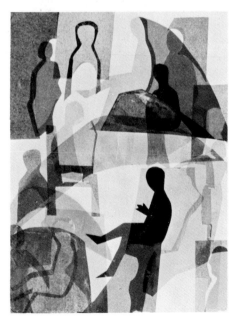

Hard edge shapes are the basic art element in *Overlay* (46 x 61 cm.) by Murray Zucker. The artist uses commercially silk-screened colored papers (Coloraid), which he cuts and adheres to illustration board.

Collection of Sanford Schwartz.

Tissue papers of various colors are cut into shapes. When they are adhered with clear lacquer to a surface, their transparency creates a multitude of new and interesting shapes.

Lutheran High School.

Color

The collagist's palette is often a table top covered with colored shapes. Such artists gather and horde bits of color, reds, yellows, greens, earth colors, whites or blacks. They can be gathered from brochures, magazines, maps, booklets, old books, posters or other original sources.

Colored papers such as tissue papers, coated papers, poster boards, charcoal papers, rice papers, crepe papers, construction papers (which fade easily), and several types of prepared papers and stick-down colors used by commercial artists can also be purchased. Gold, silver and other metallic foils can also be added to your palette.

You may prepare your own colored papers by painting swatches or sheets of color with watercolor, tempera, acrylic, casein, oils, or designer's colors (gouache). Silkscreen or block printing techniques are often used to add color in design to paper. These prepared colored papers can then be torn or cut as needed for a collage.

Besides starting with shapes of colored paper, color may be brushed onto collaged surfaces with various paints. Acrylics are perhaps the most popular, but watercolor, tempera, and oils are also used. Some artists use stains, such as tea, dyes, inks, thinned oils or acrylics, to give patina to their work.

Often, because many collages are abstract in their approach, color provides the initial visual impact. Many of the works reproduced in black and white in this book have a completely different character and visual message when viewed in color.

If you are interested in collage, your first activity should be to begin a collection of materials of various colors and shapes for your palette. More will be added as you go on, but, like a painter, you must first get the colors ready.

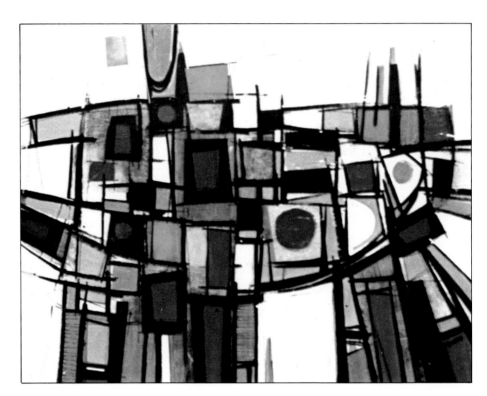

Cool colors, cut from tissue papers, are outlined and separated by Perry Owen in his collage, *Blue Structures* (122 x 152 cm.).

The contrasting colors and values used by Edward Betts are derived from a variety of papers and acrylic paint. The exciting arrangement of pieces in *Red Rockscape* (74 x 51 cm.) makes use of the elements of art arranged according to the principles of design.

The colors used by John I. Kjargaard express his private feelings about his environment. The Japanese papers used in *Mountain Landscape* (128 x 128 cm.) were painted with acrylic colors, then collaged to the ground.

Collection of Computab Inc., Honolulu.

Warm colors, cut in long, thin strips, create a hot electric movement across Margo Hoff's large collage, *Jet Orange,* (1.75 x 2.06 meters).

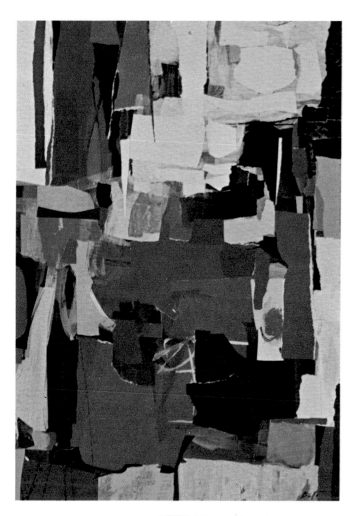

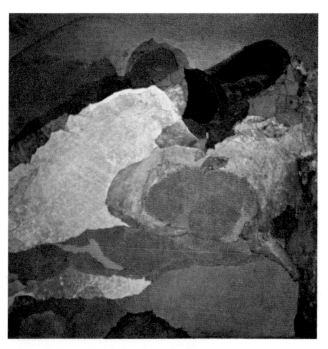

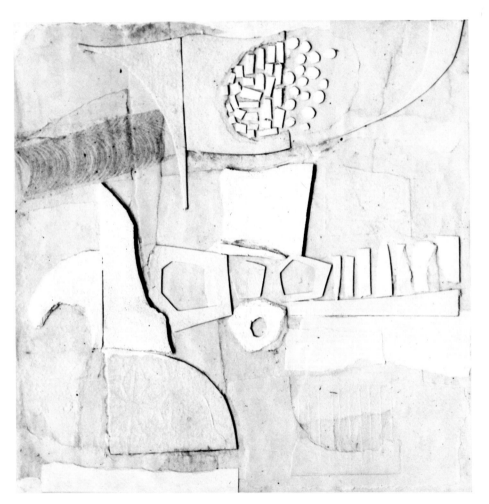

Barbara Engle's *White on White* makes use of the natural textures of many materials: rice papers, watercolor papers, drawing paper, cardboard, and cork. After gluing, the entire surface is painted white, which places emphasis on the textures and the relief of the collaged parts.

Collection of Honolulu Academy of Art.

Texture

Throughout the historical development of collage, texture has been an important element. Picasso's first collage used simulated chair caning, which was followed with wood-grained wallpapers. Soon the texturally rich surfaces of fabrics, screen, fibers and other materials were being used in collages.

Texture in collages may be actual or simulated. Many papers have heavy surface textures (oatmeal paper, some rice papers and watercolor papers) which are produced in their fabrication. Others are textured to create a receptive surface for paints or drawing tools (charcoal papers, drawing papers, canvas papers, crepe paper, or embossed papers). Roofing paper, tar paper and some industrial papers and tapes have textures that make them more useful in construction or industry.

Some textures are subtle (kraft paper, drawing paper, mirror-coated stock, or newsprint); others are boldly textured (embossed papers, corrugated cardboard, sandpaper, or paper towelling). Textures can be produced in papers by wrinkling, folding, gathering, or puckering before or during the gluing process. Sand can be added to a collage. Other textural materials, such as leaves, bark, pressed flowers, coffee grounds and bird seed can be tried.

You may wish to create textures on papers by embossing them. Drawing and printmaking papers can be embossed in a press by using sand, string, thread, glue, heavy paper pieces, or the gouged surface of wood or linoleum.

Rubbings, which also create textural surfaces, simulate the textures from which they were taken. Crayon or pencils may be used to create a rubbing.

In addition to these actual textures, simulated textures may be used. Collage artists may use newspaper pages (type, photographs) or printed magazine textures (hair, skin, trees, grass, sea, clouds, fabrics, rocks). But they also create their own simulated textures by painting or printing swatches, using a variety of media. Old prints and paintings may even be cut up and used to obtain textural richness.

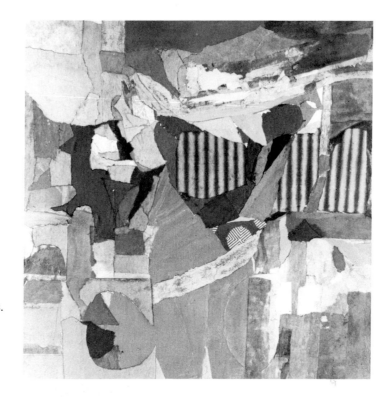

The variety of materials, their textures, and their sizes make a richly textured surface in John I. Kjargaard's collage, *Summer in Kaunakakai* (91 x 91 cm.) Many of the papers are painted before the artist glues them to the ground.

Collection of American Factors.

William Wolfram uses wrinkled, folded, and soiled kraft papers (from market bags) to develop a richly textured surface. The artist uses the wrinkles and paper build-up to add to the textural feeling found in *Land Formations*.

Collection of Mr. and Mrs. Jack Ledbetter.

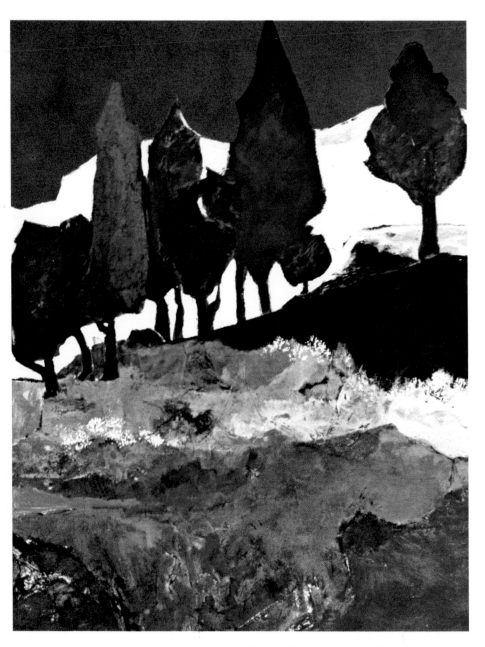

The landscape collage, *High Country* (102 x 76 cm.) by Helen van Buren, uses the conventional methods employed by other artists to show three-dimensional space.

Space

When collage artists work with land-scapes and still lifes, they often use conventional methods for showing space. Sizes may diminish in the distance, objects may overlap each other, colors may become grayed as they recede in space, or edges of objects may lead to vanishing points.

The use of collaged shapes, however, often tends to flatten objects and to eliminate the conventional feeling of depth. If depth does occur, it is often shallow. It might even be difficult to separate positive and negative space if the design is carefully worked in that direction. Where such flatness is desired, colors and values must be carefully controlled so that no forward and back movement can be felt.

In non-objective compositions, colors and shapes are often used to create a sense of depth. Warm colors seem to move forward and cool colors move back, creating a feeling of space between them. When overlapping of shapes occurs, one shape seems to be behind others. Bright colored shapes come forward and seem to stand in front of dulled and neutral colors.

Depending on the wishes of the artist, collages may appear flat, show a shallow space or seem to have great depth. To depict depth or not is the choice of the artist who must decide which way will help make the collage statement more meaningful.

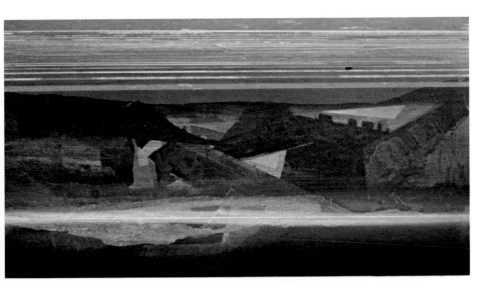

The high horizon line and bold foreground colors help to develop a sense of deep space in R. C. Benda's acrylic and collage work, *Sunken Citadel* (74 x 104 cm.).

Although the space seems shallow in Margo Hoff's collage, *Homage to Bob Dylan* (1.75 x 3.02 meters), the warm colors seem closer to the viewer than the cooler ones.

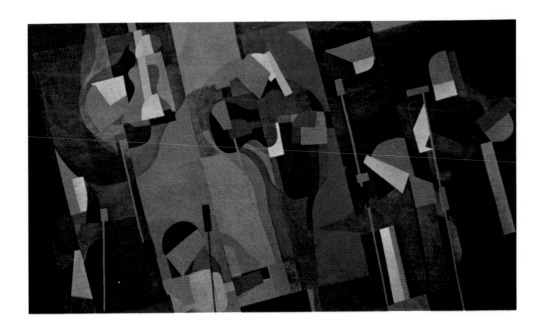

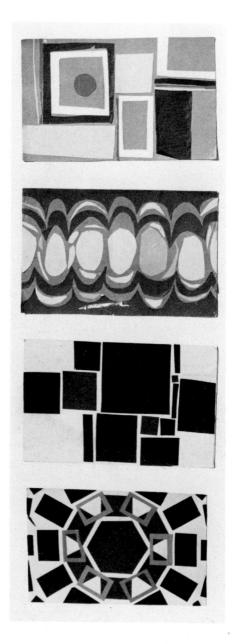

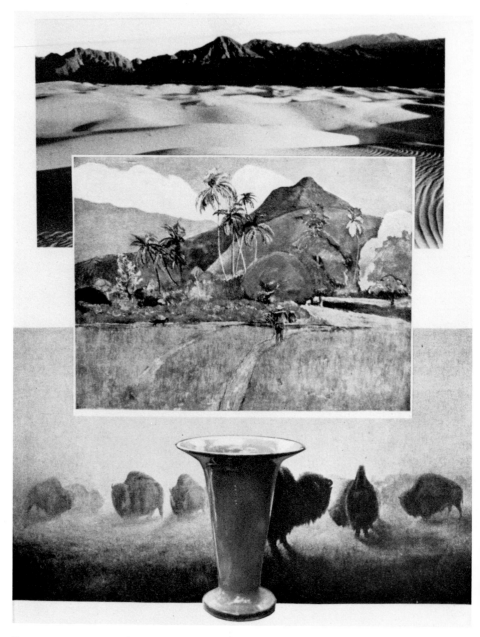

Four small studies, each 13 x 20 cm., help this student develop a sense of visual balance, using the color and value in paper shapes. Each contains a center of interest. The top three are informally balanced and the bottom design is radially balanced around a central point.

Lutheran High School.

Several color reproductions (a photograph and two paintings) are combined with the artist's own photo (cut out) of a vase in *The Westward Movement* (25 x 70 cm.) by Caroline Kent. Because the visual weight on either side of the center axis is equal, the collage is symmetrically (formally) balanced.

Courtesy of Orlando Gallery, Encino, California.

The principles of design

If the elements of design are the vocabulary of the visual communicator, then the principles of design become the grammar. They provide ways to arrange the elements in order to create well designed and pleasing statements. Since many collages are non-objective in their content, the careful composition and design of the various parts becomes even more important, because the design becomes part or all of the message.

The principles of design which help the artist arrange the pieces of the collage are: balance, variety, unity, proportion, contrast, emphasis, pattern, movement and rhythm. A look at how some collagists have worked with these principles will help you understand their collages and will aid you in creating your own collage statements.

Balance

Balance in art is a state of feeling comfortable with the finished work. Most of us are so balance-oriented in our lives that we automatically feel uncomfortable when something is out of balance. If a collage is well-balanced it will *feel* right.

Elements that can be balanced are such things as colors, values and shapes. Each of these has visual weight. Dark values and intense colors have heavier visual weight than light values and pale colors. A large shape of a color will have more weight than a small shape of the same color. However, a small shape of intense color may balance a large shape of a pale color. When arranging the shapes in collages, visual weight and balance are extremely important components.

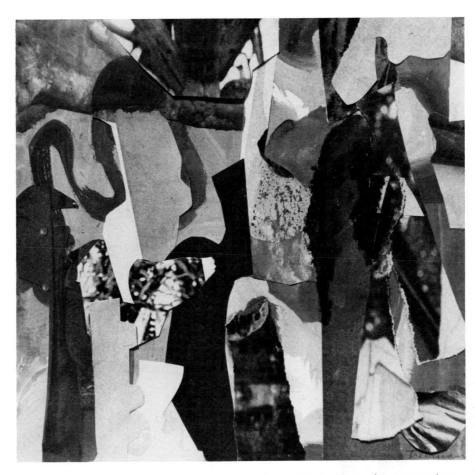

In her untitled collage of papers and casein paint (19 x 25 cm.), Joyce Treiman balances colors and values informally. While working, the artist can add paper or paint to create the feeling of visual balance.

Courtesy of Orlando Gallery, Encino, California.

Although the colors and values vary, the overall texture of the surface provides a unifying element in Howard Anderson's collage, *Blue Composition*.

Kathleen Zimmerman uses various textures, sizes, values, and colors, but arranges the parts on vertical and horizontal axes. Unity is achieved because each part of *Arroyo*, (1975), (51 x 61 cm.) is an essential part of the composition.

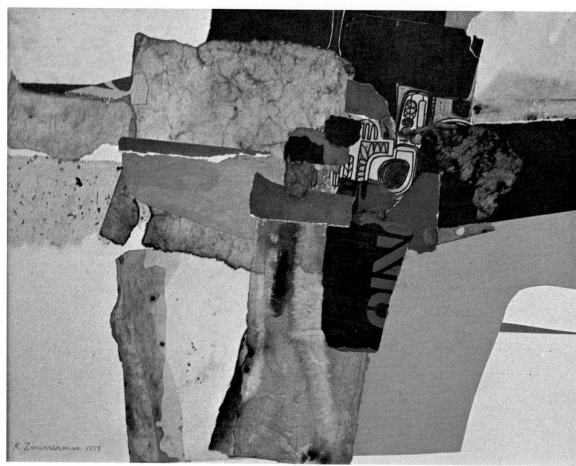

Unity

Unity in art is a sense of oneness — a feeling that everything that is in a collage or painting belongs there. Vincent van Gogh created unity in his paintings by having all the brush strokes in a work exhibit similar characteristics. A collage artist may use a single material, such as tissue paper, similar colors, such as reddish hues, or similar shapes, torn rectangles for example, to establish unity. But such drastic steps are not always necessary. There are no *rules* for establishing unity, but when all parts of the collage work together to produce a feeling of stability, unity is achieved.

Characteristics that help to establish a sense of unity might include: related colors, similar shapes — rectangular, thin, or free form, similarly-sized pieces of paper, all cut pieces of paper, all torn pieces of paper, all photographic material, smoothness, roughness, all transparent papers, or all clear, untextured papers. You can easily see that, in each of these examples, *similarity* is the key characteristic. If *most* of the surface exhibits similar characteristics of some kind, the composition will feel unified. Pattern, line and pictorial subject matter can also aid in unifying a collage. Look at the illustrations throughout the book to discover ways in which artists unified their work.

In collage, unity is a critical principle. It is easy to glue many types of objects and papers to the work, but for the collage to be successful, the objects, shapes, colors and textures must have a feeling of belonging. If they do not belong, eliminate them.

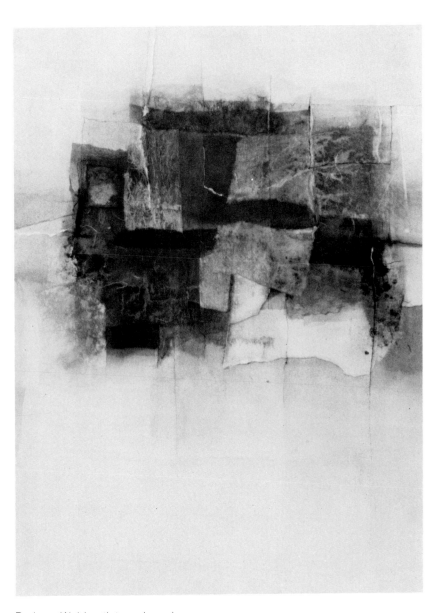

Barbara Weldon tints various rice papers with related hues so that a unifying color (this one is blue) dominates the work. The torn papers of *Blue Phantasm* (76 x 56 cm.) are glued to white illustration board. The white board emphasizes the subtle colors and values of the translucent papers.

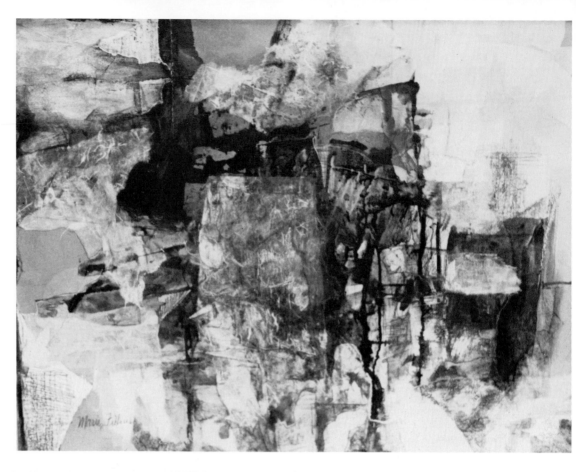

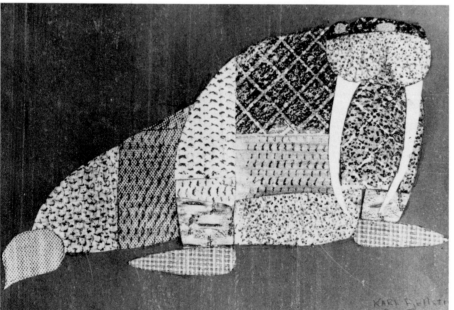

In *Upon the Place Beneath* (76 x 102 cm.), Marie Fillius uses a variety of papers combined with watercolor. Variety in value, texture, size, color, shape, and line are evident; yet, the overall textural quality produces a unified work.

The walrus is composed of a variety of crayon textures obtained from rubbings of various surfaces in the school building. Combining them into a single large shape creates the feeling of unity.

Lutheran High School.

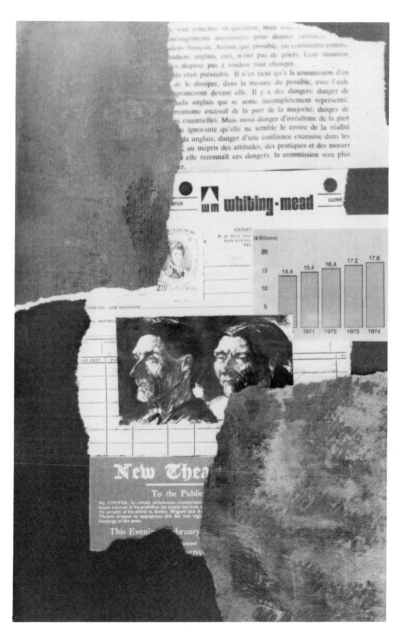

Variety

The idea of a garden full of daffodils may seem beautiful, but it could be monotonous. A few orange or red flowers would add interest and excitement to the garden, as would some rocks and green leafy plants.

While unity is necessary to the creation of a successful collage, variety is just as important. If every single element of the collage is similar, a feeling of monotony can develop. Therefore, within a unified composition, there should be some element of diversity — some variety.

If the surface is all textured, there can be a variety of textures; if it is all smooth, there may be variations in size or color. If the collage is all photographic, there may be changes in size and value; if it is all transparent, there may be some edges torn or cut. Varieties of size, color, texture, shape, paper, type, color or line will add excitement and life to the work.

While variety is desirable, *extremes* of variety can produce chaos. Too much unity *or* too much variety can be harmful to collage design — and a balance must exist. Unity is essential, variety is necessary, but both must be subordinate to the overall feeling of balance.

Several different elements make up Arthur Matula's collage, *Whiting-Mead* (30 x 20 cm.). There is great, but orderly, variety due to the simple arrangement of the parts.

The brushed textures of casein paint contrast with shapes and colors cut from magazines in Joyce Treiman's untitled collage (19 x 25 cm.).

Courtesy of Orlando Gallery, Encino, California.

Contrast

Because of the variety of materials available, collage artists have more ways available to them to introduce contrast in their work than other painters. Besides the usual contrasts of value, line and color or the contrasts that may exist in the subject matter, there is the inherent contrast of collage materials.

Contrasts in relief can be tried with the addition of three-dimensional forms. You may contrast rough papers with smooth, transparent tissue paper with opaque cardboards, or old textures with slick, new papers.

Torn shapes contrast with cut shapes. The shiny surfaces of foils can be used to contrast with the duller surfaces of regular or textured papers. Papers with decorations or lettering contrast with unaltered papers. Wrinkled papers contrast with smooth sheets.

The introduction of cloth into the collage creates an actual contrast of raw materials when used with papers. Cheesecloth or canvas, burlap or cotton will create dramatic contrasts with most papers.

Stringy rice papers offer a contrast when used with smooth papers. Introducing leaves and pressed flowers will show a contrast of shape and texture. Round cut shapes will differ from rectangular, torn ones.

An overuse of contrast can turn a collage into chaos, and restraint must be used so that the principle of contrast is not overdone. Because of the tremendous variety of materials available, collagists must keep the use of contrast under control or it can destroy any sense of unity and balance.

Value contrast is clearly evident in this paper collage by Mathilde Lombard. White paper was torn into strips and shapes, then was glued to the dark background.

Contrast in relief and texture is evident in William Wolfram's untitled assemblage. Acrylic paint and cardboard are contrasted with old furntiture and pieces of fabric.

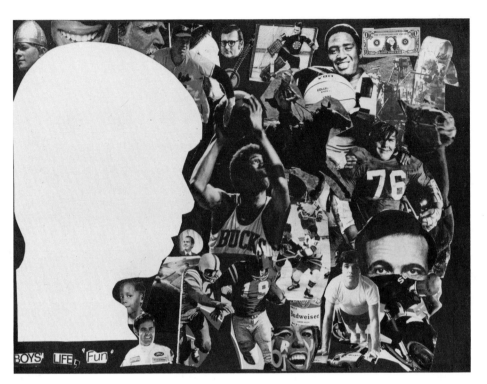

A student combines a self-silhouette with magazine material to emphasize his interests and goals in life.

Thorne Junior High School.

Emphasis

You may wish to emphasize certain aspects of your collage work. Perhaps shape is the dominant element in your work, or texture, or color, or action. You may wish to emphasize smoothness or hard edges. It may be that photographic images are dominant over cut and torn papers. Any of the art elements can receive special attention and therefore be emphasized in your work by simply using them more than the other elements.

Feelings and personal desires can be emphasized through the subjects portrayed. What kinds of items might you include in collages if you wished to emphasize nostalgia, violence, love, religion, our inhumanity to others, ecology, or sports? Perhaps action, serenity, or chaos might receive emphasis. Positive shapes might be emphasized against a neutral background. The plight of urban dwellers might be emphasized by using pieces of photographs combined with painting.

All of the methods that draftsmen and painters use to develop visual emphasis are available to the collagist, plus additional materials such as photographs, old papers, textural surfaces and found objects.

Verily Hammons emphasizes action and movement in her collage, *The Dance*. Colors, cut from magazine pages, provide the palette in her work, which takes on the feeling of stop-action photography. Pieces of torn paper are adhered with acrylic medium.

Collection of Mr. and Mrs. Emanuel Becker.

Nicholas Follansbee emphasizes nostalgia and textures in his work. He has combined old papers, old writing, old and worn endsheets from books, and old postage stamps with old leaves and flowers in a delicately composed, untitled collage (18 x 11 cm.).

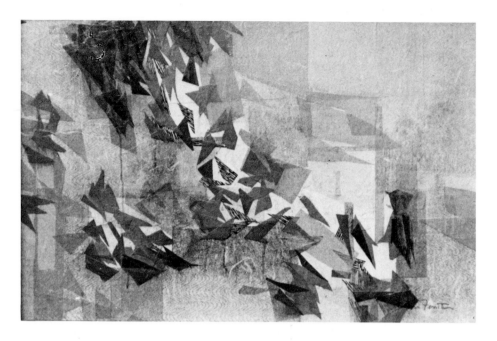

A strong sense of movement is felt in *Leaves* (61 x 97 cm.), a tissue paper and metallic collage by Clare Ferriter. Overlapping shapes and controlled colors and values lead your eye along the path of the drifting leaves.

Collection of Harcourt, Brace, Jovanovich, Inc.

The main eye movement is along a horizontal axis in Maury Haseltine's collage. From the center of the work, movement seems to radiate in many directions, but is held in check by the strong horizontal and vertical axes. Mirror, felt, paper, and lace are combined in *Say Yes, Dear* (61 x 76 cm.).

Collection of Don Olsen.

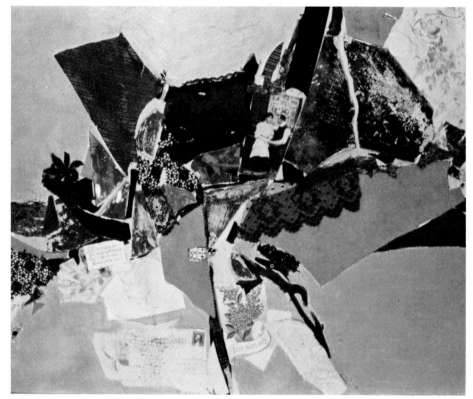

Movement and rhythm

Because many collages are abstract or non-objective in their content, the principles of design are important in order to produce successful compositions. Visual movement, leading the eye through a work, can be developed by the grouping of shapes, arrangement of values, placement of contrasting elements or colors, the use of lines, or the actual shapes of certain items.

Visual rhythms are developed by the repetition of certain aspects of your work. Colors, shapes, or lines can be repeated to produce rhythm. Regular, repeated shapes will create patterns which are rhythmic. Rhythms can be regular or irregular, depending on the placement of papers, textures, colors or shapes.

While the collages on this page emphasize movement and/or rhythm, most successful collages feature their own visual movement to direct your eye, and their own rhythmic arrangement of parts to create interest. Some artists eliminate movement and/or rhythm in their work in order to create particular effects, but the majority will use these principles effectively.

Carole Barnes uses line and shape to direct your eye in a vertical movement, from bottom to top. Notice how several horizontal lines and shapes slow down the movement and keep it from escaping from the top of the collage. Rhythms can also be felt in *Interior of A Landscape* (89 x 74 cm.), composed of torn, old paintings, combined with acrylic paint.

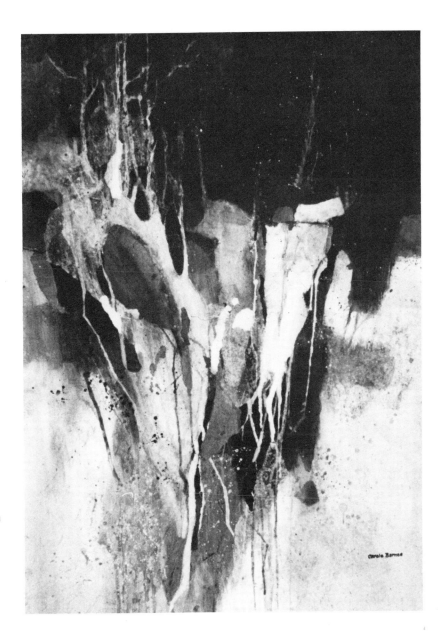

Pattern

Pattern is developed by the regular repetitive placement of certain features, such as square shapes, circles, or patches of texture or color of equal size. Like rhythms, pattern can be regular or irregular, depending on the arrangement of the parts. Because of the feeling of casual arrangement in most collages, strict patterning is not found in many works.

Since wallpapers make use of patterns, it is possible to find pattern in some parts of a collage that uses them. Ink or paint may be used to create patterns in a collage. The arrangement of windows, people or leaves might create pattern.

Pattern may be reserved for backgrounds behind your subjects or it may be used in an over-all way, throughout the work. Some artists, who emphasize a careful arrangement in their collaged designs, might make extensive use of pattern; perhaps, even emphasizing it.

Use of pattern in your collages will depend to a large degree on your style of work and the desire to communicate certain repetitive aspects.

Proportion

When the sizes of objects in a collage (or painting) relate correctly to each other, they are in proportion. A horse is larger than a rabbit. A child is larger than a sparrow. A dog is smaller than an automobile. When things are in correct proportion, everything in the work appears as it would in real life.

Nearer objects are larger than similar objects far away. A tree that is several blocks distant will be smaller than a tree several feet away. They are shown in proportion.

The various parts of a human body are in proportion to each other. Hands are in proportion to arms; feet to legs; heads to bodies. But artists may wish to change proportions drastically to create shocking situations. A large eye in a small head will be out of proportion and will create an unnatural figure. A rabbit that is larger than a horse is out of proportion and is shocking. The image of King Kong in New York produces uneasy feelings.

Collage artists work in several ways with proportions. They use correct proportions for a natural effect or they may distort proportions to create very disproportionate effects. With photographic cutouts, it is easy to create comic or shocking situations when things are out of proportion.

Paul Souza combines found papers, many of which contain pattern, with white gesso in his collage, *Structure* (41 x 61 cm.). The contrast of pattern and flat areas gives added importance to the pattern.

Because of the placement of the cutouts, the proportions in Roger Winter's *Secret Landscape #7* (9 x 11 cm.) seem correct. How could the artist have made things seem out of proportion?

Figures and objects that are drastically out of proportion can create humorous or shocking situations.

Lutheran High School.

74

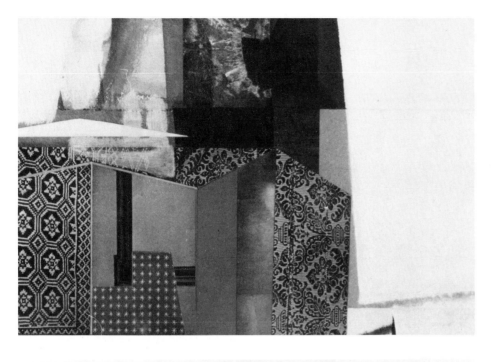

Paper — a versatile collage material

The palette of the collage artist is a table covered with various papers emptied from innumerable containers. Decide early on your storage system and file your papers in convenient groupings until you are ready to start your collage. Then prepare your palette. As you work, you can cut, tear, singe, or crumple, depending on your goals.

You may prefer to work with only one type of paper in a single collage. Or you may enjoy the challenge of using many types of paper. Some of the examples on these pages show work that emphasizes variety. Varieties in values, textures, colors, transparency, smoothness, lettering, photographic content and size are apparent. The more variety that is worked in, the more carefully the materials must be controlled in order to produce a unified collage.

Too much uncontrolled variety leads to chaos and a lack of design, although it is fun to experiment with many types of papers simply to express this variety. It may be difficult to create well designed statements using every available paper resource. It is easier to use only a few or even a single paper for your collage, if you are a novice.

The manner in which you express your ideas and develop your expression are personal factors which grow with you and your art. The system of techniques used in collage will unfold through trials and errors. Try several techniques to find your best style.

Variety is evident in Barbara Engle's collage, *In Front of Behind* (1966), (33 x 32 cm.). There is a variety of papers, in the sizes of the paper pieces, in value, color and texture. Because of a vertical and horizontal arrangement, there is a feeling of unity in the work.

Collection of the Honolulu Academy of Arts, Hawaii.

Tissue papers, rice papers, found papers, commercially printed papers, and papers prepared with oil, acrylic or ink are glued to canvas board by Kathleen Zimmerman. The papers used in *Marshland,* (1976), (61 x 61 cm.), are carefully selected and prepared for the effect they will have in this composition.

Collection of Swarthmore College, Pennsylvania.

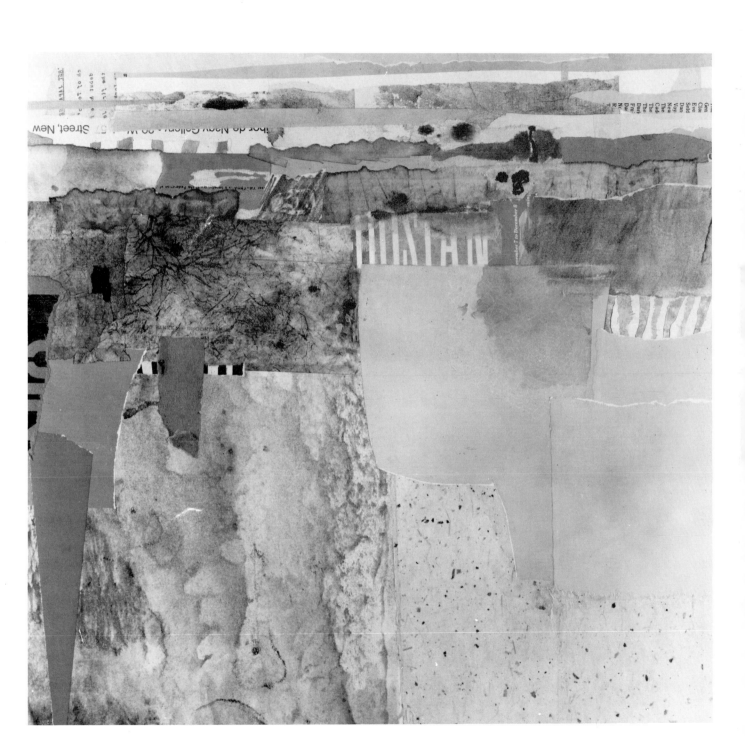

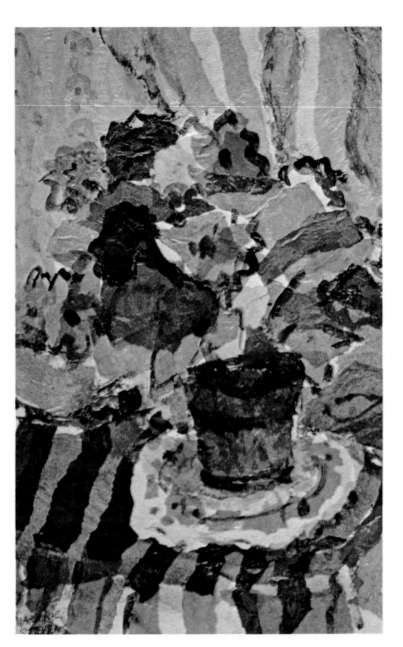

Tissue papers

We use tissue paper in various forms (wrapping, facial tissue, carbon copies, etc.) almost every day, and are familiar with its fragile quality. This inexpensive collage material, manufactured from rags, sulphite and soda, comes in well over fifty colors, depending on the source of production. Art supply stores stock a tremendous variety of colored tissue papers that are exciting in their variety. Some of the colors tend to fade easily, but others are quite permanent. A little testing in bright light will help you decide which colors will last.

For use in schools, the immediate achievement of brilliant color is a positive aspect of such papers. So is the reasonable cost and availability. Although tissue paper seems extremely fragile, when it is glued to a firm ground, it becomes very strong. The ground should be white to make best use of the translucency of the paper, one of its most important qualities. If a transparent paper is glued to a dark background, little color mixing will take place.

Colored tissue papers are combined with a few, brushed watercolor lines in Marjorie Stevens' collage, *African Violets* (36 x 23 cm.). Shadows are created by adhering a cool-colored tissue over existing brighter hues.

Collection of Mr. and Mrs. Alan Smith.

If you wish to create a particular color by overlapping various hues, experimentation will help you determine the order of such overlapping. Red over blue will produce a different hue than blue over red. If certain color mixes are essential to your collage, you should have a sample board available to work out the correct combination sequences.

Experiment with white tissue papers also, to see what effect they have on colors. Actually, before beginning a tissue paper collage, you should spend some time testing on a white practice board so that you understand the laminating techniques and the application or development of color. Tones can be deepened by gluing the same color in several layers — the more layers, the deeper the tone. Lines can be created by slightly overlapping similar or various colors. Darker valued papers are less transparent than the lighter valued ones, and should not be used if transparency is needed in your collage.

A close-up view of this still life shows the color mixing and textural qualities of overlapping hues of tissue paper. No drawing was done first. The colors were put down to give the appearance of large, painted brush strokes.

Lutheran High School.

Torn tissue papers furnish brilliant colors for an imaginary desert scene. Laminating with clear lacquer produces the transparency evident in various pieces.

Lutheran High School.

The adhering of tissue papers to the ground can be done with a variety of glues. White glue, thinned slightly with water, produces a strong bond. Acrylic medium will create not only a good bond, but will also strengthen the structure of the paper. For a very transparent quality, use clear lacquer (the thicker the better). Some glues will cause a bleeding or running effect with some colors. This effect can be used to advantage if you adapt your techniques to make use of the bleeds.

With tissue papers, almost all adhesives work best in a laminating technique: putting down the adhesive, adding the tissue paper and brushing another layer over the top to seal it in place. Try each of the adhesives to see which works best for your particular needs and techniques. Use bristle brushes to keep the glue and paper under control. Clean all tools carefully after use to prevent their deterioration.

Tissue papers can be torn or cut to shape, and can even be applied as large sheets, if care is taken to insure smoothness. But textures can be created by pushing the glue-wet paper into ridges or folds or by wrinkling just before gluing. Bubbly areas will produce a different texture as will the addition of small bits of other papers or string, under the paper.

Tissue papers can be used alone to produce dynamic results, but they are also very effective with other materials. When pieces are added over other adhered papers, the color acts like a wash or glaze, changing all the colors under it.

Arthur Matula uses various found papers in his collage, titled 24 (36 x 30 cm.). In several places he adds tissue papers that act like transparent color washes over underlying papers.

Uncomplicated subjects require only a few bits of torn tissue paper to tell the story.

Lutheran Junior High School.

As cut tissue papers overlap, the resulting deeper tones act as lines and strengthen the image of this mountain sheep.

Lutheran High School.

Ink lines are added (eyes and teeth) to detail the face of a charging lion, made from torn bits of earth-colored tissue paper.

Lutheran High School.

Rice papers

If you are looking for papers that can add textural interest to your collages, obtain some of the Oriental rice papers. The availability of this paper varies, but it is produced in over a hundred patterns with a wide range of colors, textures and weights. Some are translucent, others opaque; some contain stringy fibers, others are clear and smooth; some include leaf fragments, others seem to contain bits of straw. The variety is overwhelming and the challenge to use them is inherent in their construction.

All types are not available from all art dealers, in fact some stores have several types, some have none. Each type and style has a name, but since the selection is usually limited, you will probably look over the entire group and select a few that appeal to you.

More than twelve different types of rice paper are used by the author in *Foggy Carmel Morning* (1974), (61 x 91 cm.). Watercolor is first put down on watercolor board, rice papers are laminated over the color, and more watercolor is brushed over the glued surface. Several such layers are used in many places.

Courtesy of the Fireside Gallery, Carmel, California.

Rice papers of various types are combined with tissue papers, found papers, and commercially colored papers in Kathleen Zimmerman's collage, *Marshland Cove* (1976), (56 x 76 cm.). Some of the papers are used as they are found, others are prepared with oil or acrylic paints before being adhered to a canvas board ground.

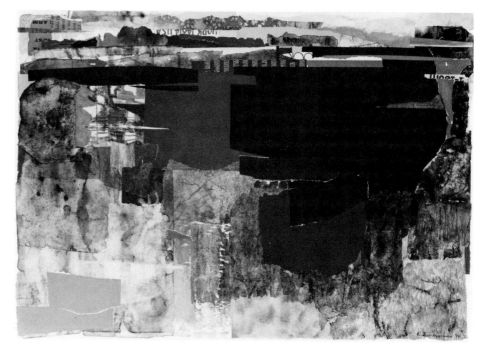

The textures, lace patterns, embedded materials, colors and translucency are features which give each paper a distinctive quality and produce fascinating results in collages. The papers are also highly absorbent and will accept paints of all kinds, as well as printing ink and drawing materials.

Rice papers can be adhered to collages with white glue or an acrylic medium. A laminating technique, like that used for tissue paper, works well, with the glue or medium thinned slightly to produce a good bond and a non-shiny surface. If transparent watercolor is used as a toning medium, only white or near white papers should be used.

The coloring of rice papers can be done before or after the gluing takes place. Papers can be stained or painted on one or two sides and allowed to dry. More color can be added until the correct hues and values are achieved. The pieces can then be cut or torn and added to the collage.

Another method involves gluing the papers in place, then painting over them. Translucent papers can also be glued over previously painted areas. An alternating collage and paint sequence can build up extremely rich surfaces.

Experimentation with various papers and additions of color will help you become familiar with some of the possibilities. Study the photographs in this and other chapters so that you can develop your own ideas.

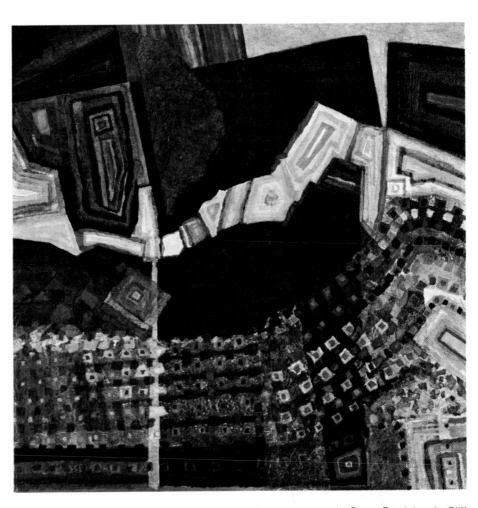

The rice papers in Glenn Bradshaw's *Cliff Face II* (76 x 76 cm.) are colored with acrylic paints before they are adhered to the gesso-covered, canvas ground. Rich passages of color and texture resemble the tortured strata of craggy cliff faces.

Prepared art papers

While many papers are free (such as magazines, wrapping paper, some tissue papers, or recycled paper bags or greeting cards) there are many papers that are manufactured for special art uses. Some are textured, others smooth; some are colored, others white; some are thin and flexible, others thick; some tear easily while others are quite strong. Only testing will help you determine which will work best in your collages. Almost all of them will glue easily to flat surfaces.

The lighter weight papers will work best for pasting because they conform easily to any variances in the surface of the collage. Thicker papers can be made more pliable by soaking them in water. Heavy papers need stronger glue or acrylic gel to adhere them properly.

Printmaking papers come in a variety of colors, textures, finishes and weights. They are absorbent enough to accept printing ink and will also accept paints and glue.

Drawing and painting papers are usually white or off-white and are excellent for use in collages.

Charcoal papers have a characteristic texture or tooth that can add surface interest to your collages. They are also available in a wide range of colors and qualities and are produced by many manufacturers here and abroad.

Watercolor papers from different companies have different textural surfaces, are white, and come in a variety of weights. The lighter weights will work more easily in collages and will readily accept all types of paints.

White papers come in a wide variety of textures, weights, and degrees of translucency. Each can be a valuable addition to a collage, but some experimenting will have to be done to see how each reacts to glues and paints.

Black and white construction papers are used to create both positive and negative shapes.

Lutheran Junior High School.

Murray Zucker uses commercially silk-screened color papers (Coloraid) which are cut and adhered to illustration board. *Montauk Sentry,* (41 x 61 cm.).

Collection of Omaha National Bank.

Arthur Secunda takes advantage of the white, torn edges of commercially printed papers in his collage, *Light at the End of the Tunnel* (51 x 66 cm.). Because the color is applied to white paper, the torn edge makes an effective linear pattern.

Origami papers are bright in color (one side only) and are very flexible, since they are manufactured specifically for folding. Packages of various sizes are produced with a wide range of colors.

Aurora papers are an American version of Origami papers and like poster papers, have brilliant colors printed on one side of the sheet only. The colors are permanent and are very flat, with a hard and durable finish.

Velour papers have a velvety finish. They are produced for use with pastels. The cloth-like surface is very pleasing as an accent in some collages.

Sumi papers and Shuji papers, imported from Japan and used for calligraphy, are excellent for collage work. They resemble some rice papers and can be obtained in many Oriental import stores.

Commercial color sheets and *art papers* can be obtained from art dealers that cater to commercial and graphic artists. Some color sheets (Pantone and Color-aid) can be cut with a stencil knife and adhered with pressure to the surface. Most of these are translucent and come in controlled tones and tints of each available color. Although the technique of application is quite different from that of most collage materials, art papers might offer some fascinating options for trial.

Construction papers have a wide range of colors, but vary in quality. Some are soft while others are more durable. The colors of all construction papers will fade easily, but can be quite effective for school use. If the work is to be permanent, such papers should be avoided.

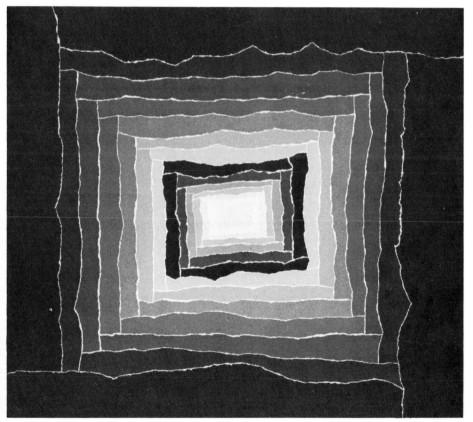

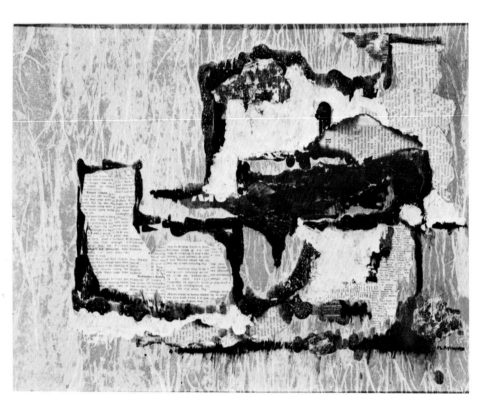

In *Jeopardy*, Michaelina Aylward combines white and black crepe paper over a gold ground, which shows through in places. Melted black crayon and newspaper are also used to complete the design.

Courtesy of Dennison Manufacturing Company.

Crepe papers

The vibrant colors and crinkly texture of crepe papers make them very appealing for collage use. They are tough and slightly stretchable. The colors, however, have a tendency to run when wet. This can be an advantage or a disadvantage, depending on your technique for gluing.

Crepe papers can be adhered with a mixture of white glue and water, or a slightly diluted acrylic medium. The bleeding quality of the brilliant colors can be used to create vigorous free-flowing statements. Ink and watercolor can be dropped onto the wet surface to supplement the natural running of colors.

Edges of crepe paper can be singed with a match or candle to create black edges which will produce a dark line effect in the collage. The paper will not flame up. When the edges are blackened, they can be dipped in cold water to stop the singeing action.

When soaked with the glue and water mixture, the crepe paper can be pushed and spread to produce ridged effects which show up as linear patterns. This maneuver can be accomplished with a stiff bristle brush or your fingers.

Crepe papers can be used as accent colors and textures in collages or can be the major paper items in collaged work. Tissue papers (white or colored) can be used effectively with crepe papers. Use the same glue and water mixture for an adhesive.

You also may want to try using only the color from crepe papers. Glue the paper to a collage and after a few minutes, remove the paper while it is still wet. The color will remain as a crinkly stain on the collage.

Try experimenting with crepe paper. You will discover other ways that it can be used in your collages. Because of the large size of crepe paper rolls, and because of the absorbent quality of the paper, large surfaces can be glued with comparative ease.

epe paper and tissue paper are
hered with a white glue and water
xture in Michaelina Aylward's collage,
enaissance. The black areas have been
nged before being glued to the ground.

urtesy of Dennison Manufacturing Company.

Preparing your own papers

You can also prepare your own papers to create special or unique effects. An entire book could be written about the experimental preparation of swatches of paper, but a few ideas should get you started on your own. After preparation and drying, the papers can be collected, sorted by colors or textures, and saved for future use. Later they can be cut or torn into smaller sizes for collage use.

Painting can be done prior to gluing by brushing colors (acrylics, watercolors, oils, poster paints) onto pieces of drawing paper or typewriter paper. Paints can be mixed, washed or partially scraped off, depending on the effects you want or the direction your experimentation takes.

Silk screening can provide you with smooth surfaces of bright colors (single colors, mixed, overlapping, bleeding or textured, depending on the techniques you use).

Spray paints can be applied directly, obliquely, on flat or crumpled surfaces or with stencils to give a rich textural quality to papers. *Spattering* with brushes (toothbrushes or bristle brushes) can accomplish similar results.

Scorching, singeing or *partially burning* papers of various types can produce fascinating alterations.

Crushing papers and holding them under water (before or after applying tempera or other paints) will create a crinkly effect, similar to batik.

Sandpapering or *erasing* on found or prepared papers will add texture and feeling of age.

Waxing papers by dipping, or making many wax crayon markings on paper can produce a wide range of special effects.

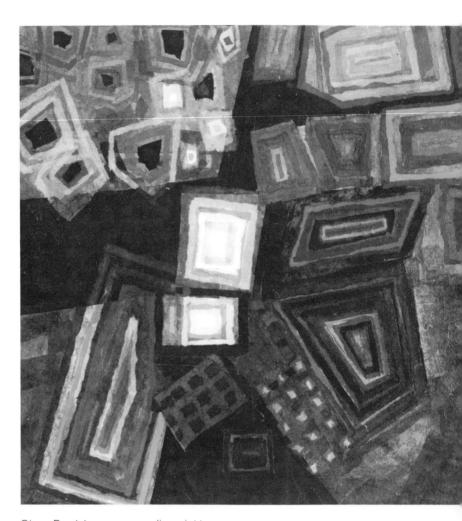

Glenn Bradshaw uses acrylic paint to prepare his rice papers (some on both sides) before using them. *Cliff Face I* (61 x 61 cm.) has a great variety of colors and papers.

Floating oil paint (diluted with turpentine to a runny mixture) on a pan of water will transfer fascinating designs to a sheet of paper dropped on the surface. Patterns can be altered by stirring with a stick or piece of cardboard. Add color, change the kind of paper you use, use flat or crumpled paper or vary your printing techniques for other possibilities.

Monoprints, made by applying poster paint and/or watercolor and/or colored inks to a glass sheet, will provide many interesting textures and surfaces.

Crayon rubbings can provide texturally rich swatches for gluing. Try brushing contrasting or complementary colors of watercolor over the rubbings for more dramatic results.

Printing of sponges, fabrics (cheesecloth, burlap), crumpled paper or other textural surfaces with tempera paint (or casein, watercolor or water soluble inks) can introduce many and varied textural surfaces into your selection of collage materials.

All wet materials should be placed on flat surfaces or hung from pins until dry. Because too many wrinkles will prevent solid adhering, the sheets can be ironed lightly to flatten them. Dampening them slightly with a spray of water and stacking them between blank sheets under pressure will also produce flat sheets for later use.

Once you start to experiment in the preparation of papers, the sky is the limit as far as variety is concerned. It would be advisable to accumulate a large stockpile so that you have a large selection from which to choose.

Throughout the book, you will notice that all of the techniques listed above are used by the artists, usually in combination with other papers and other painting techniques.

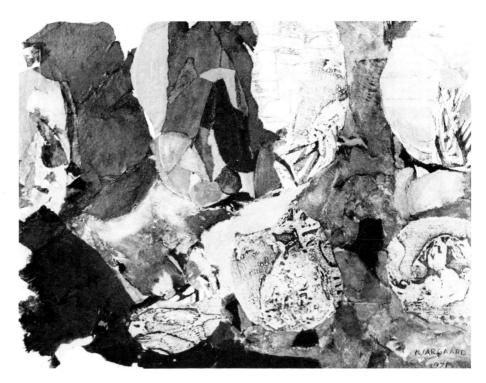

John I. Kjargaard spatters, prints, and brushes acrylic paint on various papers, including Japanese rice papers. When dry, these multicolored and textured sheets act as a palette from which the artist tears and cuts shapes as needed. Many of his preparation techniques are evident in *Haleakala* (46 x 61 cm.).

Collection of Mr. and Mrs. Lawrence Pricher.

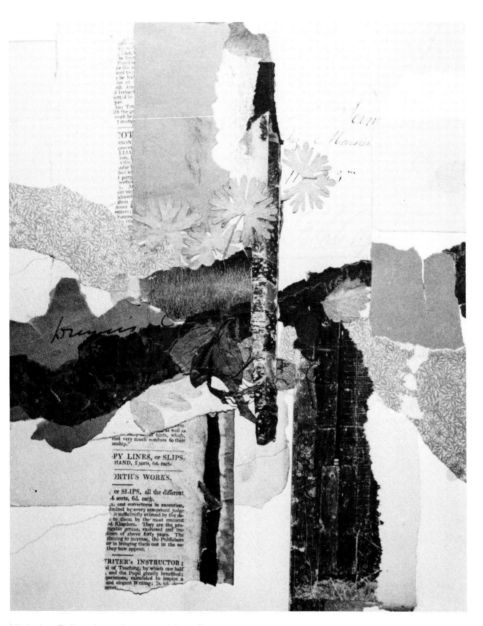

Novelty papers/wallpapers

Art stores are not the only source for obtaining papers for collages. Gift shops contain brightly colored wrapping papers and greeting cards. Your closet might yield a box crammed with old wrapping papers that you couldn't bear to throw away.

Shelf papers (some are self-sticking) can be found in various stores (hardware, supermarkets, notion departments) and come in a vast array of colors and printed patterns.

Papers with gold or silver flecks or solid metallic papers can be used. Various foil might add interest or contrast to your collages.

Plastic sheets, mylar and reflective materials might be incorporated into collages. You might find it possible to use some of the wide variety of plastic and/or paper tapes or stick down materials in your work. Decals and gummed labels might also be useful.

A trip to a paint and wallpaper store will provide you with more ideas. Paint swatches and an entire library of wallpaper sample books await your inspection. Perhaps you can contact a local dealer who will give you sample books of old patterns which you can use for collage material.

Be on the lookout constantly for non-art papers that can add color or texture to your supply of collage materials. It was such material (wallpaper and oil cloth) that ignited the collage idea in the inventive minds of Pablo Picasso and George Braque, and began the chain of art developments that has grown into today's unparalleled collage activity.

Nicholas Follansbee draws on his collection of old and discarded books to get papers for his collages. This untitled work, (24 x 19.5 cm.) contains bits of covers, end sheets, pages, and spines, as well as other papers and a few leaves.

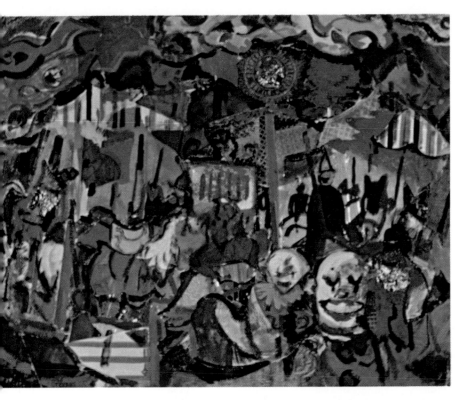

Marjorie Stevens draws on her vast collection of novelty papers to create *Circus* (48 x 61 cm.). Wallpapers, greeting cards, wrapping papers, and other printed and plain papers are part of her palette.

Collection of Jack Traster.

Pattern and colors from papers acquired in Greece are used by Ilse Getz in her collage, *Mykonos Window* (30 x 41 cm.).

Magazines and photographs

There is a wealth of collage material available free of charge, and no trips are needed to pick it up. Magazines and newspapers contain an abundance of colors, textures and letters that are stimulating and challenging. Some collage artists use only magazine materials in their work while others may use them as accents or contrasts. Various adhesives can be used with such papers. You should try a few to see which one works best with your techniques.

Magazine illustrations (black and white or full color) can provide actual pictorial material for your work. You may cut out houses, people, trees, cars or animals to collage. You may use eyes, ears or hands to compose new figures. You can rearrange the parts of many visual images to create new statements.

You may wish to combine some photo images with other photo images or with painted or prepared papers. You can combine your pasted images with painting or drawing to explore collage ideas. A sheet of pasted images could be the raw material for cutting up and regluing to another backing.

You may take your own photographs to include in part or wholly in collages. Post cards, calendars, booklets and brochures can add to your stockpile of photographic collage resources.

Nigel Henderson uses only papers from magazines to create his *Head of a Man* (1949). The artist felt that there was so much variety in this single material that he did not need other papers.

Collection of The Tate Gallery, London.

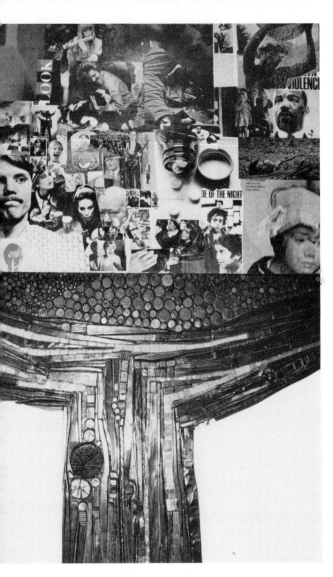

Reinhold Marxhausen combines maga-
zine images with a wood mosaic in his
large wall mural, *Redemption* (183 x 122
cm.). Notice how the variety of images
and their arrangement adds interest to the
photographic section.

The congested scramble of intense bas-
ketball players is dramatized as arms and
legs from several photographs are rear-
ranged and collaged to the photographic
background.

Emerson Junior High School.

Illustrative material from magazines, newspapers, brochures and other sources can be used for their colors and values, disregarding their original contexts. Such textures and colors can be used for themselves, regardless of the fact that they were hair, cloth, sky or wood in their first life. Now they are yellow, brown, blue or gray textures, a palette for your collages. You can gather envelopes full of greens, reds, blues and dozens of other hues. Keep them ready for use in either figurative or non-objective collages.

Collage artists, like painters, have many ways of expressing themselves. Some work in representational ways, others more abstractly. As you look through this book, you will see the tremendous variety of expression that includes photograpic materials. You can incorporate such ideas and build around them or they may trigger new ideas in your mind. But no matter which methods, techniques or styles you use, take advantage of free collage materials. They are practically unlimited.

In *Picasso Mort,* Ethel P. Margolies combines some images of the artist and his work and newspaper headlines and articles about him with some rice paper and brushed lines. Colors are purposely kept subdued in commemorating his death.

Prague, (1967), (44 x 59 cm.) is primarily composed of colored magazine papers with acrylic paint added as the artist, Shirley Moskowitz, saw fit.

Collection of Dr. and Mrs. John Cutter.

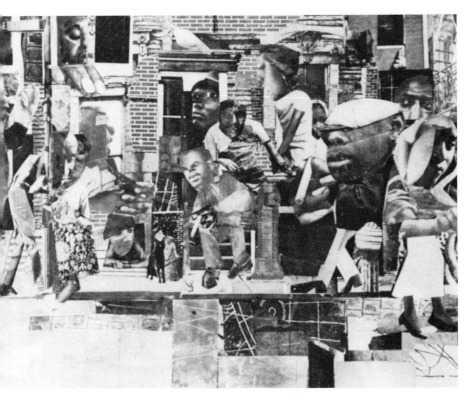

Romare Bearden cuts magazine illustrations into pieces and rearranges them to create personal visual statements. In *The Dove* (1967), the artist forcefully communicates with us in regard to life in congested urban areas.

Dynamic action is recorded in Verily Hammons' paper collage, *Going to Blazes* (76 x 102 cm.). The subject is sketched first. The entire collage, composed of colored materials from magazines and some bits of tissue paper, is finally coated with white shellac.

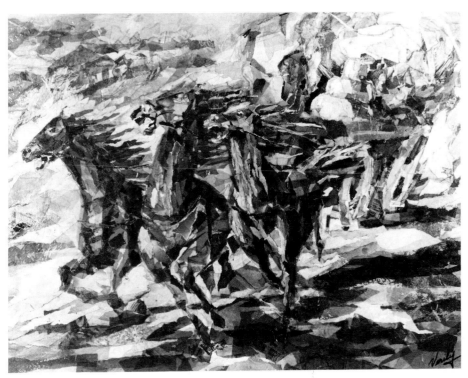

A small and interesting abstract design is first located (with the help of a small, 5 x 8 cm., finder or paper frame) in a magazine illustration. Other magazine colors are then collected, torn, cut and glued to reproduce the found design in a larger (46 x 61 cm.) size

Lutheran High School.

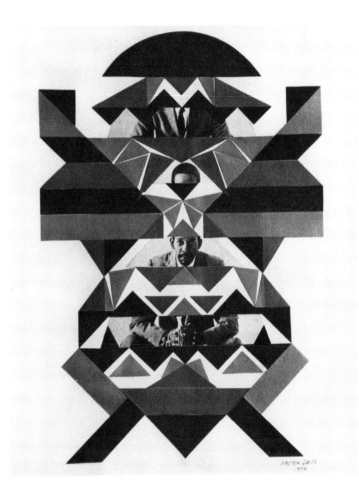

Pat Tavenner combines photographic
material with pieces of mirror and other
papers to create *Foreign Woman* (1964),
(25 x 20 cm.). (© Pat Tavenner)

Walter Davis combines a single cut-up
photograph with commercially printed,
colored papers (Pantone) in his unique
arrangement, *Jazz Totem — Kenny
Durham #1* (51 x 41 cm.).

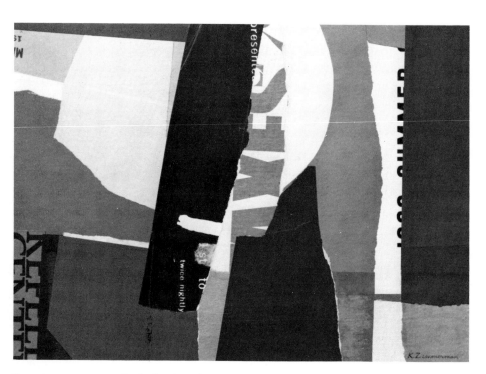

Found papers, many including lettering, are glued to canvas board by Kathleen Zimmerman. *Spring Tide* (1973), (26 x 37 cm.) makes use of the shapes and textures of letters, rather than the words themselves.

Using lettering

Some of the first collages that Picasso, Braque and Juan Gris produced used words, partial words or lettering to suggest newspapers or music scores. A cross section of collages produced since those early examples will reveal a constant interest in the shapes and textures of letters, used singly or massed together.

Magazines and newspapers are prime sources for lettering. Newspapers might seem too fragile for collage use, but if acrylic medium is used as an adhesive, the paper will become extremely durable. The soft gray color of the paper and the huge variety of type styles and sizes can provide you with a large selection of collage materials. Solid blacks, large letters or numerals, fine type, photographic grays and white space offer a wide range of values and textures which can be the basic material for collages, or can provide accent and/or contrast in your work.

Entire words can carry the message or words may be cut up to provide only their characteristic shapes to enliven a collage. Some artists make use of the various weights of letters and manipulate them as a complete palette of gray values.

Lettering might simply be incidental to the papers used, such as tickets, stubs, printed matter or lettering on paper bags or cards. Letters might even be added to a collage by stenciling, painting or printing. Handwriting (either found on old papers or added to the work) may also find its subtle way into some collages.

Newspaper lettering and a few partial pictures from newspapers provide the texture and gray values for Si Lewen's collage, *General XYZ* (1959), (122 x 61 cm.). The cut and torn papers exhibit a variety of type sizes and styles and are glued to a tinted canvas ground.

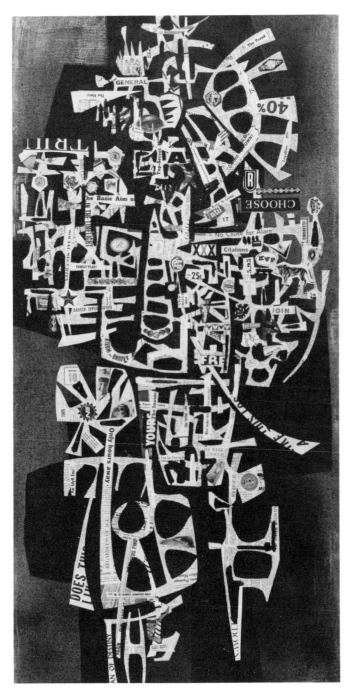

A

B

The delicate collages of Tad Miyashita usually include lettering, of some sort. The shapes and patterns of the lettering become important ingredients in the collages, sometimes acting as transparent textures and at other times shouting for attention. *Posted* (A) and *No Trespassing* (B) are both 61 x 61 centimeters in size.

Recycling old paintings and prints

A collage artist looks everywhere for materials for his/her work. Even the artist's own collages are not safe. They may find themselves cut, torn and reused in new collages.

Look through a stack of old paintings (watercolors, caseins, acrylics or temperas) or prints of all kinds. If they are torn up into smaller pieces, their colors and textures can find new life in collage form. Entire collages might be built from such work or only parts may be included. For example, you may simply use one painting, cutting or tearing it up, and rearrange all the parts to produce your collage. Or you may use two entire paintings to create one new collage. Or only parts of several paintings may be used.

Parts of collages themselves might be recut or retorn and added to new work. The rich textures or colorful accents of one work might provide just the right material for your present collage. If the weight of previous work is too heavy for the glue you are using, try acrylic gel as an adhesive.

So, if you are working with collage, don't throw away any usable raw materials, even early examples of your own work.

Cardboards

Many varieties of cardboard are manufactured for use as disposable containers. Corrugated cardboard, however, has certain properties that are appealing to artists. It is light in weight, cuts easily, is absorbent and when torn apart, has special textural features that collagists like. It glues easily and, when layered, has great strength. The lettering on some cartons might be useful in collage, but the surface is easily painted with all water based pigments, except transparent watercolor.

Poster board and chip board are heavier cardboards that do not have the corrugated texture. They are more difficult to cut, especially the heaviest weights, but when glued down, can provide a strong relief surface for more collages or painting. (See Ben Nicholson's work in chapter 1).

Tag board and other lightweight boards (such as railroad board, matt board, bristol board or other specialized heavy papers) can be used almost like paper, but may need acrylic gels to hold them in place. They may provide a change in surface relief in complex collages or can be the only material used. They may be painted or used in their natural colors. Tearing of all cardboards will produce ragged edges that could be very interesting. Cutting with a matt knife or razor blade will leave very hard and crisp edges and create a completely different feeling in the collage.

Arthur Matula combined several kinds of papers with corrugated cardboard in an uncomplicated but effective collage (36 x 30 cm.). Notice how the distribution of the various papers creates continuing lines (edges) and an easy balance.

Parts of the rocky mountainside of *Hilltown Impressions* (1971), (56 x 76 cm.) are made from scraps of previous collages. More rice paper and watercolor are added by the author to build up the richly textured surface.

Courtesy of Challis Galleries, Laguna Beach, California.

Condensed Motorcycle (76 x 102 cm) is a joyous jumble of shape and line cut from pieces of cardboard. Margo Hoff used acrylic paint to add color, and had to use a strong adhesive to keep the cardboard in place.

Jack Selleck combines corrugated cardboard and acrylic paint in his collage, *The Bride and Groom about to Embrace* (1975), (76 x 102 cm.). Using such heavy material helps achieve a feeling of simplicity and places emphasis on large shapes.

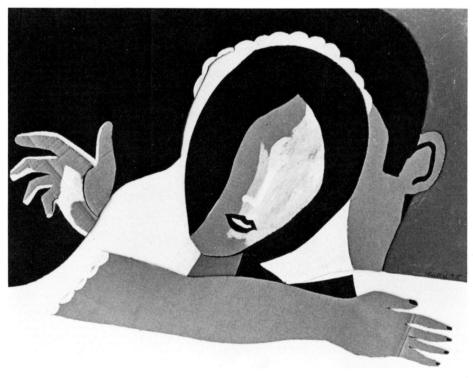

Corrugated cardboard and bond paper
are collaged on canvas by Ronald
Ahlstrom in his work, *Composition,* (182
cm. long). Dark brown and tan tones are
colored with oil paint to enhance the rich
textures of the materials.

Paper collage and drawing

5

Although many collages involve only the use of papers of various colors and textures, artists have experimented with the addition of other media throughout the development of collage techniques. In its early stage, collage and drawing or painting always went hand in hand. The collages of Georges Braque always included drawing, while those of Pablo Picasso and Juan Gris used either drawing, painting or both.

Initially, the collage was an addition to drawings and paintings, but gradually artists used more and more collage materials and less and less drawing or painting in the work. Today, artists work in both directions. Some use only cut and torn papers while others use varying amounts of paint or drawing media.

The amount of drawing and its importance in the work is up to the artist. All the drawing media (ink, pencil, charcoal, pastels, conte crayon, and wash drawings) can be used with collage. Sometimes drawing is added to a collage and at other times collage is added to drawing. The result should be harmonious and achieve a feeling of unity so that both elements, collage and drawing, work together. If one element seems obviously added on, the result will be uncomfortable and some additional work will be needed to produce a unified composition.

In *English Lemons* (53 x 36 cm.) by Don Lagerberg, the artist used found papers mounted on a wood ground, but added pencil and pen and ink lines to complete his design.

Courtesy of Orlando Gallery, Encino, California.

Juan Gris uses pasted papers in places, but draws with crayon for line and shading and adds oil paint to color some areas. *Breakfast* (1914), (80.5 x 59.5 cm.), is done on a canvas ground.

The Museum of Modern Art, New York, acquired through the Lillie P. Bliss Bequest.

Pencil and pen and sepia ink drawing are combined with watercolor and rice paper collage in a type of montage. In *Impressions of New England* (1976), (61 x 91 cm.) by the author, the large white shapes are first collaged, then the drawing, painting and gluing are worked out.

Courtesy of the Fireside Gallery, Carmel, California.

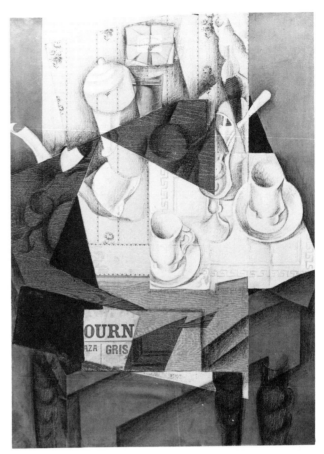

Collage and pencil/charcoal

Pencil or charcoal and black and white visual material can easily be combined because the values and textures work well together. But there are many ways to use such materials, as these illustrations show.

One or a few black and white illustrations can be glued down and pencil drawing can expand or connect them in realistic, sketchy or humorous ways. A few sketches before gluing will help put things in the proper place.

Drawings can be made on paper, which can then be cut or torn and rearranged in collage form. Drawings can also be made of collages or the combination of drawing and collage can be carefully thought out in advance to produce just the right feeling or expression.

Care should be taken in gluing collage material. Excess glue should be avoided or cleaned up because pencil or charcoal will slide over such slick areas producing a different quality of shading. It might be necessary to use a spray fixative on these collages to prevent smudges. Or an acrylic medium can be brushed over the entire surface, which acts as a sealer.

A student glued part of a magazine photographic illustration to drawing paper, then continued to develop the values and shapes with pencil.

Lutheran High School.

Several black and white magazine photos were cut into parts and glued down to make an imagined arrangement. Pencil drawing was used to complete the image.

The collaged material at the top was cut from magazines. The student, using perspective, values, shading and form, then made a drawing of the collage, selecting the most appealing parts.

John Marshall High School.

Linda Ronstadt (42 x 42 cm.) is a carefully shaded pencil drawing by Richard Adkins, with collage in the matted area completing the total design.

Courtesy of Orlando Gallery, Encino, California.

Corinne West Hartley developed experimental ink textures on pieces of paper. These were combined with pen and ink drawing in a figure study (41 x 30 cm.). Doodled ink lines help unify the composition.

Collage and pen and ink

The black lines and shapes made with India ink will combine well with black and white photographic materials. The only care that must be taken is that the printed visual pieces should have some strong value contrasts (very dark blacks and bright whites) to match the strength of solidly inked lines and shapes.

Several approaches can be followed. You may draw first and add collage material or you may collage several items to a white illustration board or heavy paper and begin tying them together with inked lines. Shapes, patterns or lines can be drawn to duplicate patterns already in the collage, or you may provide patterns that will outline or unify the composition.

Your working process might be something like this: draw; collage, draw; collage; draw. Continue working and reworking until you like the result.

Build your collage around a theme, such as the city, animals, airports, zodiac signs or abstractions.

Take ink or marker pen drawings from your sketchbook or portfolio and cut or tear them to use in collages. Some additional inked lines can tie the parts together for a unified composition.

Swatches of inked textures and patterns can be used as collage material. Blotting, spattering, monoprinting, crosshatching, doodling and dripping can produce a wide selection of textures to use.

India ink can be used with colored tissue paper to outline shapes and objects. If you are working on white illustration board or heavy drawing paper, a pencil outline will help to keep collaged colors in place. You may also try gluing tissue colors (use white glue or clear lacquer) without such initial sketching. When done, the collage *might* benefit from additional lines, either heavy or light. The lines separate various parts from the background.

Colored inks can be used to change the tones of tissue paper, if you desire such alterations. Colored inks can also be used in the drawing process, especially if colored papers (tissue or magazine colors) are used in the collage. You may create work similar to the black and white studies, but use colored visual material and brightly colored inks, applied with pens or brushes.

As you can see from the examples on these and other pages, combinations of ink and collage can range from very simple to extremely complex. Some are humorous or incongruous and others can be quite serious. Some are sketchy while others are very accomplished. As you work on such combinations, you will learn more about yourself and your developing style of art.

Parts of a city were drawn, others were cut from magazines and glued to a sheet of tagboard (56 x 71 cm.). Pencil, ink lines, and washes were used to create a feeling of unity.

Hollywood High School.

Heavy, brushed ink lines cage the tissue paper colors in this still life, creating a stained glass window effect.

Lutheran High School.

Pen and ink lines were used for the detail, while tissue papers add the color in this student still life. The lines sometimes outline bubbles and value changes, but at other times are independent of the color shapes.

Hollywood High School.

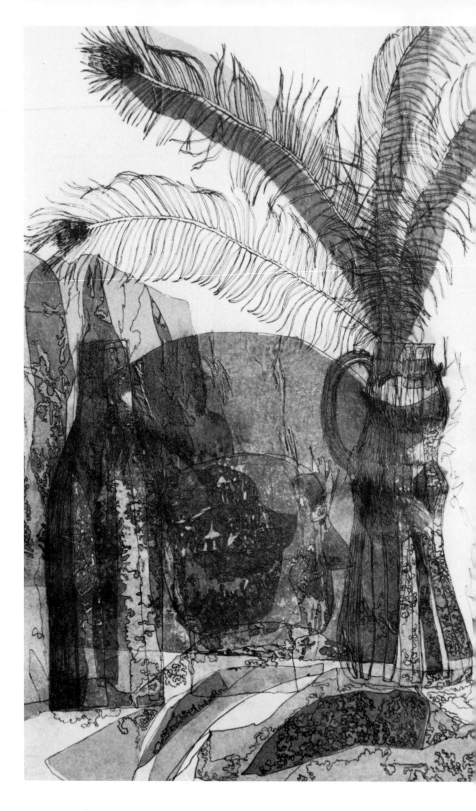

Bolin combined drawing and collage
a unique way. All the grayish, textured
as are made from his handwriting. In
center of this untitled work (27 x 93
.) one of the "pages" is collaged, the
er is drawn on the illustration board
und.

rtesy of Orlando Gallery, Encino, California.

Collage and mixed media drawing

The challenge and enjoyment of experimenting with various drawing materials (wet and dry; waxy and watery) can be doubled with the addition of collage materials in the work. Textures, patterns, colors, patinas and other visual effects can enhance mixed media drawings, developing beautifully enriched surfaces.

Combinations of drawing materials are numerous. Surround yourself with crayons, ink washes, sticks and pens, ink, watercolors, glue, soft papers, razor blade and scissors. Then pick up some tool or paper and get started. Working from a model, still life, sketchbook or your imagination, use a variety of tools and materials. Keep adding or subtracting. Glue down and tear off. Draw, glue, draw, add washes and keep using other materials.

You may wish to limit the number of materials and tools, or you may use as many as you can find. There is no set procedure for starting such a work. You will be developing a unique working style and technique. Perhaps some of these examples will get you started, but the challenge is developing your own approach to combining mixed media drawing with collage.

Strips of paper with horse racers and bulls are pasted over black paper, which is on an illustration board ground. A fiber tipped pen, white prismacolor (crayon), and ink washes were used to finish the design. Ann-Marie Kuczun's *Wall Street — 3:30 PM* (61 x 76 cm.) resembles a photographic proof sheet.

White glue was applied randomly in the background space, and pieces of soft gray paper of several values were pressed onto the surface. When dry, the loose parts of the papers were torn off, leaving ragged edges in places. Over this textured background, a bead of white glue was put down over a penciled outline. Pencil, watercolor, tempera, and charcoal was used to further develop the work (61 x 46 cm.).

Nightingale Junior High School.

Pencil, pen and ink, and wash drawing are combined with collage in George Ketterl's untitled work (54 x 56 cm.). The fragmented collage emphasizes the beauty of the graphic materials used.

Courtesy of Orlando Gallery, Encino, California.

This surface is worked with pencil, ink, collage, and yellow tempera for an interesting approach to the figure. Blowing through a straw pushed some of the wet ink around, while a stick and ink were used in other places.

Gardena High School.

Paper collage and painting

6

Since the initial collage ideas of Picasso and Braque, painters have been intrigued with the possibilities of combining painting and collage. Some painters add collage to their work; many collagists add paint to their work. Whatever the major emphasis is in your work, using paint and collage together can be very effective.

The first collage additions were made to oil paintings. Later both transparent and opaque watercolorists made use of collage to strengthen their design or to add surface interest to their paintings. With the invention of acrylic paints and the acrylic mediums, collage took on new importance. The transparent mediums and acrylic paint itself make excellent bonding agents for collage.

Some artists like to have their collage additions become a dominant part of their work. There are some artists who use the added papers to enrich the surface during the painting process. You might not even see many of the papers, so carefully are they worked into the painting. Both modes of working are worthy of notice, as are the many variations in between.

As you look at examples in this chapter and in other parts of the book, you can generate ideas that will give your own work a unique direction. The ways of combining paint and collage are so numerous that they cannot all be included here. Artists and students are always developing new approaches and techniques. As you try different techniques, it is exciting to consider the possibility that your exact methods may never have been used before.

Joseph's Coat (204 x 81 cm.) by Margo Hoff has a built-up surface of lightweight cardboard and heavier cardboard pieces. The relief surface was colored with acrylic paints.

Collection of Sally Fairweather.

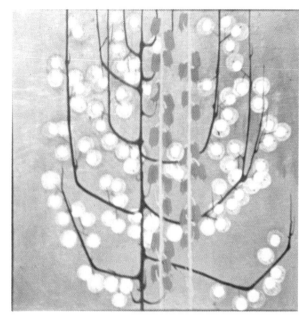

Helen van Buren used papers for both color and texture, but added acrylic paint to enliven some color areas and to tone down others. *Bowl of Flowers* (61 x 91 cm.) is vibrantly colorful.

Money Plant (61 x 76 cm.) includes Japanese papers, tissue papers, and gold leaf in the collage, but James Varner Parker used acrylic paint to add the branches.

John Kjargaard applies acrylic paints to rice papers before collaging, and then may add more paint at a later stage. *Heavy Seas* (46 x 61 cm.) is composed of two large sheets of prepared paper and a few smaller pieces.

Collection of Dr. and Mrs. K. Y. Lum.

In *Morning at Two Lights* (56 x 76 cm.) by
the author, transparent watercolor was
first put down in large masses. Several
types of rice paper were then glued on top
of the painted areas, to be followed with
more watercolor until the statement was
complete. In some areas the collage is
evident, in others it is completely inte-
grated into the painting.

Collage and transparent watercolor

When combining transparent watercolor and collage, it is possible to work in two directions. One direction would stress the transparency of the medium; the second would emphasize the added collage pieces.

The transparent feeling of watercolor can be preserved if all the collaged papers that are used are white, or nearly white. Rice papers of many textures, drawing papers, other watercolor papers, charcoal papers and other absorbent white papers are good for this approach. Try gluing first and painting over the textured surface. Or paint large masses first, then add white collaged papers and then more watercolor. Thinned white glue can be used as an adhesive but care should be taken so that it does not become too thick. The watercolor will not apply well in that case. Heavy glue will form a resistant coating and the watercolor will roll off to surrounding absorbent papers.

Some areas may be collaged, painted, collaged and repainted several times to develop the surface you are looking for. Spattering and dripping can supplement the paper textures. Lifting of color can be accomplished only if the color has not penetrated into the soft papers.

Because of the transparency of watercolor, it will not color darker papers. Yet these dark papers could be used for accent or partially covered with opaque white papers so only edges show. After some trial collages, you will become familiar with the kinds of papers you wish to use and what might be done with each of them.

There are other ways to use transparent watercolor in collage, as these visual examples will show. Old paintings might be cut up and parts used in collage. A painting might be designed to be fragmented, cut up and/or rearranged. White papers (whole sheets or torn fragments) can be painted with watercolor, then adhered to the work, perhaps with more color added after the gluing is done.

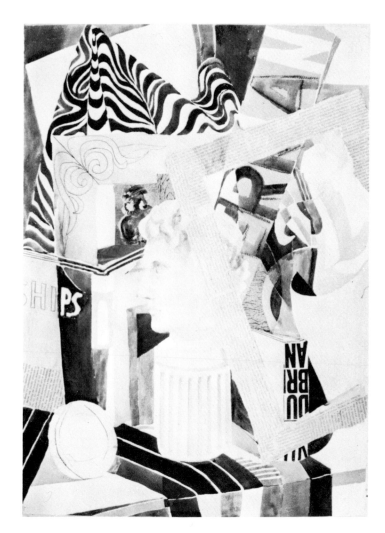

Pieces of printed lettering from magazines were glued to watercolor paper and combined with watercolor painting in this student still life.

Gardena High School.

117

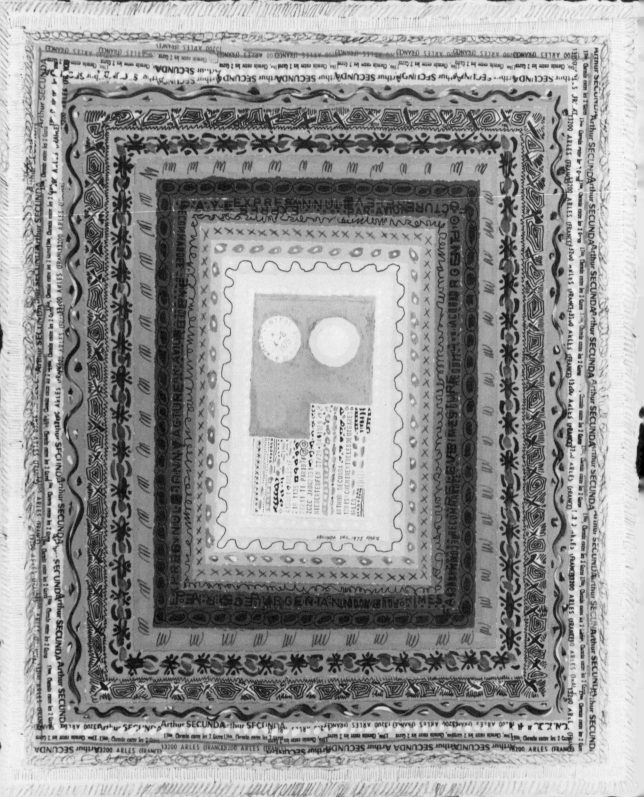

Some artists combine watercolor and collage very meticulously, so that the collaged additions melt into the work. Other artists might wish to have the collaged parts become a dominant aspect of the work. Pieces of paper will remain pieces of paper and will not be transformed into water, rocks or houses. Parts of a watercolor still life might feature the collage, while other parts stress the painting.

Lines and/or color can be added to glued shapes to start the collage. More of each can be added as work progresses, or the original combination might have substance enough to leave it alone.

Torn edges will create an organic feeling that could lead to a work with an emphasis on nature. Cut edges might produce feelings of machines and technology.

The directions you can go with combinations of watercolor and collage are many — from representational to pure abstraction, and the many variations in between. Collage might help you free yourself from the rigid duplication of nature, or it might allow you to see the abstract qualities of form and shape in your environment. It can help traditional watercolorists expand their techniques and concepts of a medium which is often considered non-experimental.

Verily Hammons carefully combined watercolor and various pasted papers to create *Downhill Racer*. Most of the papers (watercolor papers and rice papers) were painted first with watercolor, then torn and glued in place.

Collection of Mr. Walter Foster.

Bon Jour, Paris (1975), (61 x 46 cm.) by Arthur Secunda is a collage which combines sheets of paper, watercolor, ink, and a bit of printing.

Collection of Arras Gallery, New York. Photograph by Charles Anderson.

Tissue papers of various hues were adhered to white illustration board in general shapes. India ink lines were combined with white casein paint to delineate detail, establish unity, and change colors and values in certain areas. *Hilltown Impressions* (1968), (36 x 69 cm.) is by the author.

After many elements from magazines were collaged to a tagboard ground, tempera paint was used to fill in the negative spaces and in an attempt to unify the colors, values, and shapes in the work.

Lutheran High School.

Collage and opaque watercolor

Because opaque watercolor (tempera, poster paint, casein and designers colors) can cover the images and colors of a collage surface, the variety of techniques is greater than those available when using only transparent watercolor. Areas can be overpainted, have collage materials added and overpainted again. There is more flexibility and change possible during the developmental processes of building the collage and painting combination.

Several directions can be taken. You may paint a series of colored sheets to be used later in the collage. Rice papers, drawing papers or other smooth or textured papers (which should be thin and durable) can be painted with solid or variegated colors with any of the opaque watermedia. If the papers are too heavy, they will curl and be difficult to glue down flatly. Thinner and more flexible papers will adhere to the grounds more easily. These painted papers can be torn or cut as needed and glued to collages as finished colors, or may be painted over in the further development of the work.

Sometimes you may wish to paint separate items in a collage (for example, still life objects) and then cut them out and collage them in your own arrangement.

You may begin by partially painting the surface of a heavy paper or board and then adding pieces of color, texture, figures, flowers, signs, lettering, faces, eyes or other visual materials to the work. This may be followed with more paint and still more collage. Think of a face done in this technique. Care should be taken to unify the surface. Try to make the visual additions and the painted parts work together. If this is not done, the work will seem fragmented and unfinished. The quality of the surface should have a feeling of consistency — a feeling that all the parts belong. With a little care this can be achieved and the work will feel unified.

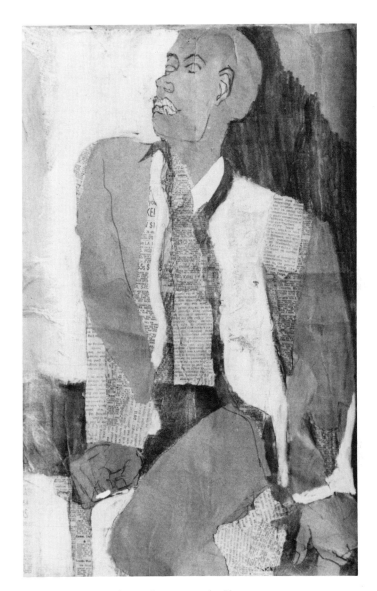

Tempera paint and pencil were used with torn pieces of newspaper in a sensitive figure study, 61 x 41 cm., done from a classmate's pose.

Gardena High School.

A relief surface can be built up, using cardboards glued to a strong backing. Various papers and weights of cardboard might be used, which can then be given a solid coat of white house paint or gesso. Strings, sand, leaves and found objects might be glued down also (sand can be sprinkled onto the wet glue) before the white paint is added. Such a surface can be given an overall patina with a single, thinned color, or can be painted with as many colors as any other painting.

Try combining brilliantly colored, transparent tissue papers (glued to a white surface) with opaque watercolors. Opaque whites, colored inks, black ink, and colored paints will work well with these papers to produce dramatic results.

While rice papers and/or crepe paper are still wet with glue, drip or spatter inks, tempera or other colors onto them and watch the color spread and blend. Some exciting combinations can result. These may be fascinating to watch but difficult to control or to make into representational subjects. It may be wise to use the textures, colors and happenings as abstract elements in such compositions, and employ them as the actual subject matter of the work.

The proportion of collage material to paint can vary dramatically. Some works have a small bit of collage while others may have a completely collaged surface with a small amount of paint added. Surround yourself with your raw materials (paint, glue, papers, cut outs, magazines, scissors, brushes and water) and reach for the items and tools that you need as you go along.

Many collages seem to work best if they are allowed to grow and develop rather than to pre-plan them from the start. The processes of selecting and rejecting, gluing, painting, covering, adding, drawing and/or scrubbing away are all useful, stimulating and necessary in this type of collage development. The opaque paints allow for instant changes of direction in your work. Soon you should feel comfortable working in this way.

Of course, opposite techniques may also be used. Such collage and paint combinations can be thought out, planned and sketched before beginning. Visual materials and paint can be applied with great care and exactness. The results of these two extremely different approaches toward collage will be completely varied, yet both can use exactly the same materials. Naturally, between these two extremes, there are many possible ways of working with such combinations of materials.

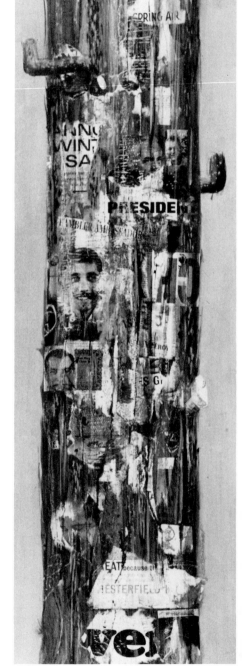

Tempera and casein paints were used with magazine and newspaper to create a collage, which simulates a telephone pole, plastered with decollaged signs and posters (91 x 30 cm.).

Lutheran High School.

Heavy cardboard rectangles were glued to a hardboard ground, followed by lighter weight papers and sand. The entire relief surface was given a coat of white paint (gesso, latex house paint or casein). Watercolor, tempera paint, and ink were used to color, outline, or patina various places. *Mediterranean Village* (1967) (51 x 76 cm.) is by the author.

Collection of Mr. and Mrs. Charles Cavanaugh.

Dozens of flowers were first made by gluing tissue papers on heavy white drawing paper. These were cut out and again adhered on another ground to produce this bountiful bouquet, placed over a painted vase..

Carver Junior High School.

The quality of Joyce Treiman's casein brush strokes contrast pleasantly with the images clipped from magazines. The colors and values of this small, untitled collage (25 x 19 cm.) work together, however, to unify the composition.

Courtesy of Orlando Gallery, Encino, California.

Rough paper toweling is torn into strips and collaged to chipboard with casein glue. Over this textured surface, casein paint (made in the classroom from dry skim milk, colored pigments, and water) was brushed on to create a personally meaningful image.

Lutheran High School.

Ruth Gewalt glued papers to a Masonite ground to suggest water crashing on rocks. In *The Cove* (51 x 71 cm.) she used opaque watercolor to strengthen some shapes and to help complete her statement.

Collage and acrylic paints

The formulation and production of acrylic polymer paints gave artists a medium that seems ideally suited to the many techniques and materials of collage. Because of its flexible, adhesive and preservative qualities, acrylic paints are ideally suited for collage, far surpassing transparent and opaque watercolors in usefulness. Liquid matte and gloss acrylic mediums and gels can be used as adhesives and then combined with color to create glazes for the work. The mediums can also be used to seal the final surface, preserving it from moisture and dust. The heavier gels can be used to adhere heavy paper, found objects, metal and other non-paper items to the surfaces of collages.

Because of the durability and strength of acrylic paints and mediums, they will combine well with any paper in most of the varied techniques discussed in the book.

Thinned acrylics (glazes) can be combined with tissue paper collage to add transparent color over the surface. Values and colors of the collaged pieces can be changed without destroying the transparent quality of the papers. Tissue paper can be soaked in acrylic color or white and pressed into place in a collage, creating wrinkled but sturdy surfaces which can then be glazed or painted over.

Amy West begins her collages by gluing papers to canvas, then paints over the surface with acrylics. *Blithe Spirit* (1976), (122 x 102 cm.) exhibits the artist's mastery of her technique, as subtle color and value changes take place inside the larger and more dominant shapes.

Acrylic products (paint and mediums) are combined with collage in a natural and free-flowing way by Carole Barnes. In *Winter Woods* (74 x 89 cm.), the artist used paper shapes as part of the scene, while the brush strokes, spatters, drips, and runs of the acrylic paint suggest other landscape elements.

Although Edward Betts' collage, *Coastal Fragment,* is small (41 x 30 cm.), the simple shapes combined with slashes of acrylic color produce a feeling of greater size and strength.

Cut paper shapes were combined with acrylic paints (thick and thinned) and glued to a fiber board ground, in Ronald Ahlstrom's *Untitled #1* (1971), (51 x 46 cm.).

Some flowers were cut from the pages of magazines, others were painted in this collage, which combined magazine papers and acrylic paint.

Lutheran High School.

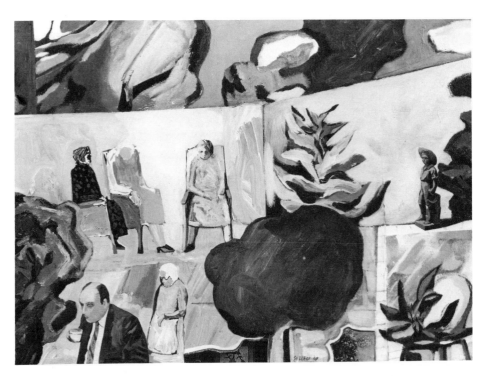

Try brushing colored glazes over collages made from photo images, either black and white or color. Dramatic changes will result in the mood and appearance of the found materials. Acrylic glazes added over textured papers can create a patina-like effect and further enrich an already textured surface.

Acrylic paints can be used in both opaque and transparent techniques. Collages with paint-like surfaces are possible when acrylics are used with their full intensity. Such work can combine paint with found images and/or shapes of colored, textured and/or white papers or cardboards.

Because of the durability and flexibility of the acrylics, many layers can be glued and painted on top of each other. By gluing, painting, gluing, painting and gluing many times, the surface may actually resemble a low relief sculpture. Many layers of many materials can be used until the desired result is achieved. And the result will remain strong and durable.

After sketching his composition for *Patio Figures*, (1969), Jack Selleck glued figures from magazines to the ground and painted over them with acrylic paints. This technique unifies the composition and creates a painterly surface. Not all the figures in the work are treated this way, some having no collage at all.

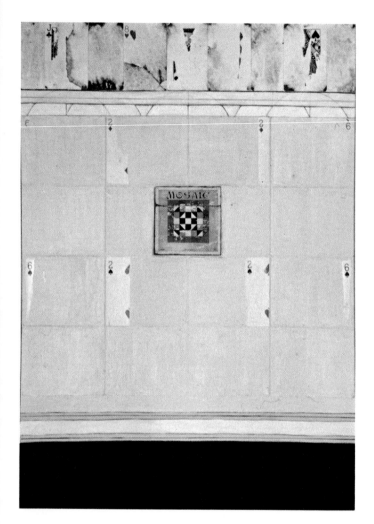

Acrylic paints can be peeled from old palettes or can be spread on glass to dry and then peeled from that. These free formed shapes can be adhered with acrylic medium to a collage surface as accents or color additions.

Gather a selection of papers, tissues, magazine materials, found shapes and objects and a sturdy backing board and experiment with ways of combining them with an acrylic medium and paints. Try several combinations. If you are excited by several of the possibilities, develop some larger collages with the materials you like best. Because the acrylics work well with so many materials, there can be a tendency to use too many different things, causing a chaotic effect. Limit yourself, once you have experimented, to the materials that will help you express your ideas best and most simply.

Ilse Getz used found papers and acrylic paint in composing her large collage, *Mosaic* (178 x 91 cm.), which is done on a canvas ground.

Arthur Secunda skillfully combined acrylic paint and collaged parts in *The Ant and the Aphid* (1965) (46 x 28 cm.), from The Watts Series.

Collection of Ron Cooper.

Painted paper, cloth and serigraph parts were combined with acrylics and mounted on plywood in P. Mansaram's *Rearview Mirror* (1967) (122 x 122 cm.).

Collection of Irving Zucker.

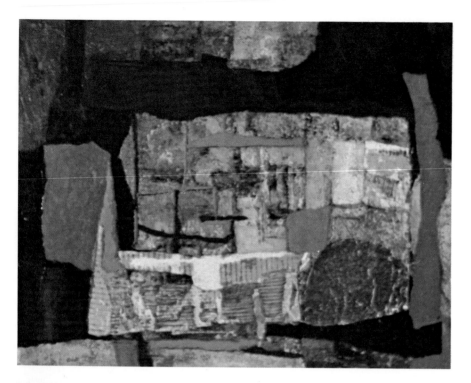

Collage and oil painting

Although the first collage activity by Picasso and Braque was carried out in their oil paintings, there are relatively few artists today who combine these two elements in their works. Other paints, particularly acrylics, are move convenient and easier to use with collage, so more people use them.

The staining quality of oils on paper produces some provocative textural surfaces that cannot be duplicated with other paints. Using canvas, canvas boards or primed Masonite surfaces, paper can be adhered with either acrylic medium or white glue. This must be done on dry surfaces or the bond will not be permanent. Gluing can be done on the original backing material or on painted surfaces that are completely dry. You may begin by adding collage to parts of an old oil painting to see what the possibilities are. Experiment with papers of various textures, thicknesses, absorbency and color.

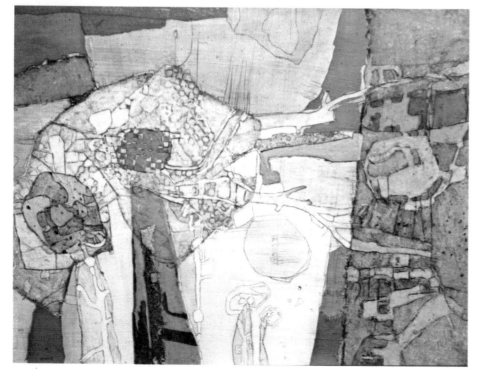

Rich colors, stains and textures are the result of combining rice paper, cardboard, corrugated board and oil paint. Ida Ozonoff created a beautifully textured surface in *Night City II* (1966) (61 x 76 cm.).

Collection of Mr. and Mrs. Peter Harris.

In *Mid Summer* (1976) (61 x 81 cm.), Ida Ozonoff makes use of rice paper and cardboard which are stained and painted with oil colors. Both the collage and paint remain visible and important parts of the work, resulting in an interesting balance of materials.

Collection of Bradley Galleries.

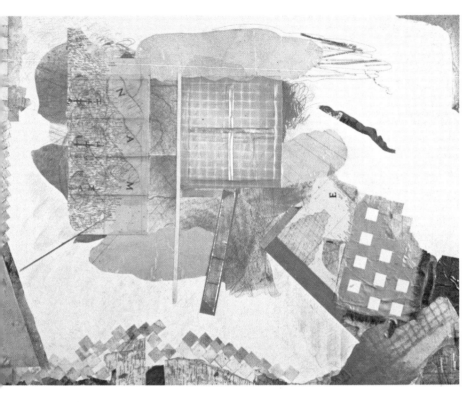

If you start with a new surface, plan the arrangement of your shapes carefully. Lay various papers on the backing and shift them around to get the most satisfying design. Vary the sizes, thicknesses, shapes and textures to keep the surface interesting.

Begin applying glazes and stains and watch the action of color on the papers. When the result seems to satisfy your requirements, stop and allow the materials to dry. More paper and thicker paint may be applied. Line can be brought in if necessary. Lighter values may be reintroduced by further gluing or using lighter valued opaque or translucent glazes or solid colors. The variations in technique and the many combinations of paper and paint can produce a vast array of stimulating surfaces in your work.

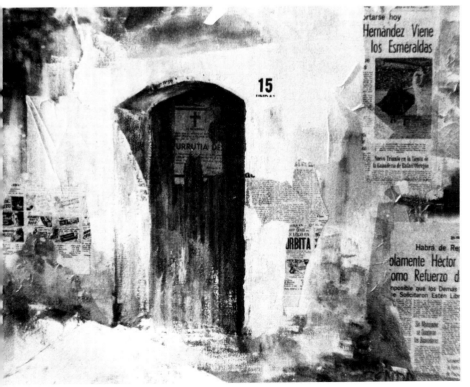

Joan E. Tanner makes use of maps, tapes, found papers and other papers on which she spatters and paints with oil colors. *War Marks* (1974) (56 x 71 cm.) produces a feeling of an aerial view of a part of earth.

Collection of Frank Hurseys.

Numero 15, (1969) (46 x 61 cm.) by Richard R. Benda was built up of papers, newspapers, and oil paint to produce the feeling of the poster covered walls of a Mexican villa.

Paper Collage and printmaking

7

Since most printmaking is done on paper, there are numerous ways in which collage and printmaking can be combined. Some are traditional and others make use of the latest technologies. Some are actual printmaking techniques while others use prints to create collages. Experimentation is a vital ingredient in both contemporary printmaking and collage making. Combining the two processes can produce some fascinating results. Many of the examples shown on the next few pages involve technical processes and equipment that might not be available to you. However, the ideas which these examples bring about might be carried out with materials that are easy for you to obtain. They also illustrate the wide range of expression that several artists have developed.

Part of old prints (woodcuts, linoleum cuts, intaglios, serigraphs or lithographs) can be cut up and used as collage material. These parts can be combined with drawing or painting to give a second life to discarded work. Or complete collages might be built up using only parts of old prints. Some prints might be made with the idea in mind that they will be used in specific collages.

Perhaps figures, faces, houses, or animals from cut or torn prints can be used. Maybe the textures, colors, or shapes would be helpful in a collage. Old prints can be torn and used just as you would use the textures, lines and shapes from magazine illustrations. Experienced collagists seldom discard any paper material, either plain, painted, or printed. There is always a possibility that it can be used at some future time.

R. C. Benda combined pieces of intaglio prints (etchings) with other paper collage and some acrylic paint to produce *Descent* (1976) (51 x 61 cm.). A second life was thus given to the print material as it became an important part of a new collage.

Collection of Computer Innovations.

On a cloth background, Hannelore Baron placed etching material, other papers, and pen and ink line drawing. *Collage with Letters* (15 x 23 cm.) is small in size and makes use of numbers and letters a part of the composition.

Courtesy of Kathryn Markel Gallery, New York.

Gloria Rosenthal worked on a plywood ground, combining oil and water monoprints, colored pastel papers and spray paint to obtain a hazy and mysterious effect. *Gamma 1-2-3* is part of the artist's Twilight Series in which she also employed several photographic and technical techniques.

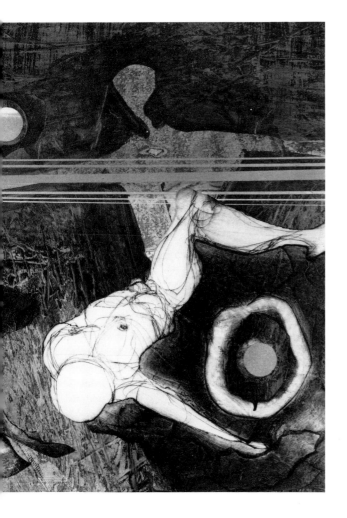

Joan E. Tanner used oil spray paint and stencils applied to transfer paper, which was glued to a sturdy ground. In *2 Stairs* (1972) (58 x 74 cm.), pencil was used for its linear quality, but stencil printing was the dominant element.

Printing with stencils can create textures and colors for use in a collage. Spray paint and stencils can be used directly to create shapes, textures and colors in a collage work. Experimentation with such combinations of techniques may suggest still other methods of expression. Using some of these directions in your work may lead to completely new and unique techniques.

Relief prints, such as linoleum, woodcut and string prints, can be made on brightly colored tissue papers, using oil based ink. When these are dry, they can be glued to a white paper surface with white glue or acrylic medium. Variations of the process can be developed by tearing or cutting several prints and layering them, overlapping each other, to produce a new printed subject. Because of the transparency of tissue papers, the images may be flopped and used on either or both sides, thus doubling the possible uses of the original print. You may print many parts (for example, fruit, flowers, bowls, jars) and paste together your own still life. If you use clear lacquer as the adhering medium (which makes the papers very transparent), you may use either water-based or oil-based inks to do the printing. By using papers with complementary colors or contrasting values, other exciting combinations can be created.

Prints of various types can be made over sheets that are already pasted. Absorbant papers, such as rice papers, drawing papers, and printmaking papers, can be glued in patterns or random arrangement. When dry, they can be overprinted, using relief blocks, serigraphy, stencils and spray paint or various monoprinting techniques. Perhaps, after the printing, some additional gluing will be needed to modify values or colors. But, if the work is satisfying, no other steps need be taken.

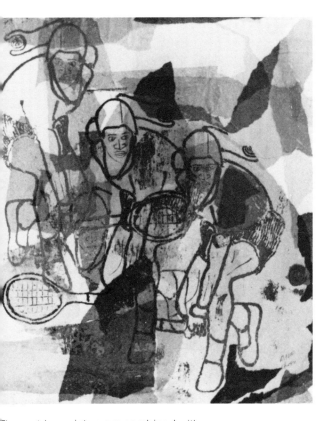

Three string prints were combined with tissue paper collage. The bird has been printed on a collaged surface, while the other subjects were printed on tissue sheets, then glued in pieces to illustration board. Notice the repeated and flopped-over images.

Lutheran High School.

If you have access to certain printing equipment, you might like to experiment with other collage possibilities. Duplicatir or copying machines can be used to mak copies of collaged materials, including fu color. Arrangements can be changed or parts added or deleted until you achieve the desired results. Type, handwriting, photographs and drawings can be combined and interchanged. Some copiers w even reproduce three-dimensional materials, immediately transforming them into two-dimensional images. Be sure you ur derstand the basic working processes of the machines before using them.

Various techniques of photo etching and lithographic printing can be used to develop collage ideas. If you are not familia with such processes, perhaps you can work with someone familiar with them ur you have developed the skills necessary for such work.

Perhaps you have other technical skills (photography, printmaking, or other repro ductive technologies) that can be incorpo rated into some form of collage. The future will see many such new processe and you may be able to contribute to the growing field of technology in art.

Untitled (1968) (57 x 39.5 cm.) is a lithograph by Claes Oldenburg. It includes n only traditional lithographic techniques, but also some innovative ones. The prin has the appearance of a collage, with taped and pasted images.

Los Angeles County Museum of Art, lent by Mr. and Mrs. David Gensburg.

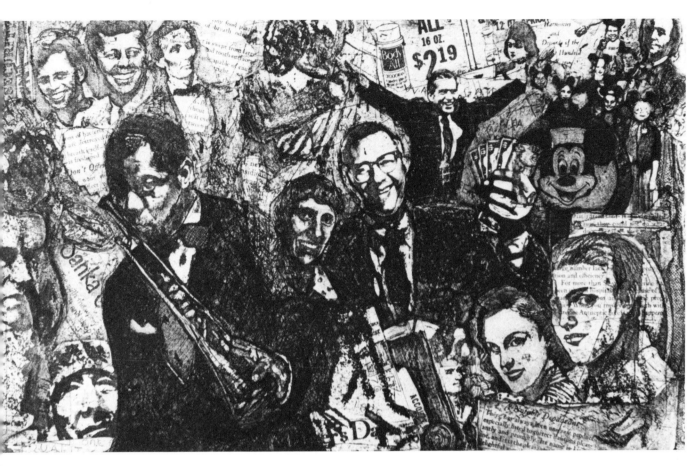

Harmonies and Discords of the First 200 Years (19 x 31 cm.) by Shirley Moskowitz is a photo-etching made from a collage of positive transparencies developed with KPR on a zinc plate. Experience with photographic techniques and a creative spirit are needed to develop such works.

Ina Dar used a 3M Process copy machine to print *Brush* (30 x 23 cm.) in full color. The print was made in a matter of seconds from a three-dimensional original arrangement.

Courtesy of Orlando Gallery, Encino, California.

Prints made from actual fossils were adhered to a canvas ground. Sand, brown kraft paper, black paper and prints made on newspaper were also glued to that ground. *Fossil Series #6,* (1954) (152 x 102 cm.) is a large collage by Lois Bartlett Tracy.

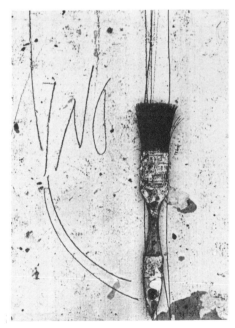

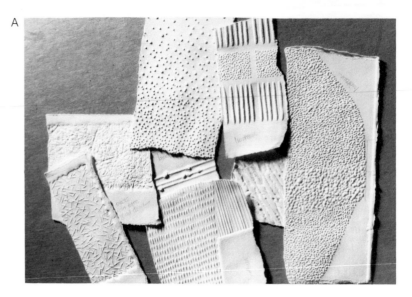

A

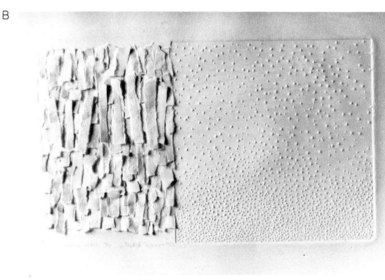

B

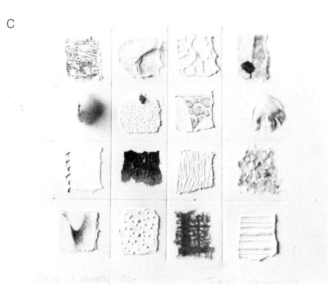

C

Creating textures: embossing and rubbing

If you need textured papers for your collages, there are several ways to produce your own. For example, wax crayons or other drawing media can be used to lift textures from existing surfaces. Place a sheet of bond paper or newsprint over a textured area, hold it steady with one hand, and rub the side of a crayon over it to pick up the texture. One color or several can be used. Try shifting the paper slightly for each color. Look for variety in the textures you work with, rubbing smooth, rough, mechanical, or natural surfaces.

If you use wax crayons as your rubbing medium, applying watercolor or diluted ink washes over the rubbings enhances the textural feeling. Complementary colors or contrasting values will add to the textures and create stronger images, because the wax will resist the added washes.

A printing press is another way to produce textures. Thoroughly dampen the paper by soaking, sponging, or holding it under a faucet. Experiment with drawing papers, printmaking papers, or other papers that are heavy enough to hold their shape after

Judith Ingram makes her own interesting textures (A) by using a press, heavy printing papers and various original relief surfaces. *Soon There Will Be Violets* (B) (28 x 47 cm.) and *Song of Myself* (C) (21 x 21 cm.) display some of the ways the artist uses these embossed textures.

embossing. Most rice papers are too soft for this process. You can then place string, feathers, found objects, bits of cut or torn tagboard or other heavy paper, sand, or other objects on the plate of the press. Lay a sheet of dampened paper and one or two thick felt blankets over the objects and run them through the press. This process should produce a variety of embossed textures for use in your collages.

Cutting in linoleum or wood with knives, linoleum or wood cutting tools, or electric tools, such as drills or routers, are other ways to prepare special embossed textures. Pounding nails or other objects into wood and removing them creates other textural surfaces. You may choose to use a combination of techniques, but keep in mind the future use you will make of these textured papers.

s fanciful animal and the bird have their
rt in wax crayon rubbings from various
rfaces found in the art room. The bird's
xtures are complemented with water-
lor washes. Pieces of the rubbings are
n or cut and assembled to make such
eatures.

heran High School.

Collagraphs will produce a mirror image. The ink-stained plate (of cardboard, sand, string and papers pasted on heavy folio board) is on the right and the resulting print on the left (30 x 22 cm.).

Lutheran High School.

The two figures on the sofa were made from string, cloth, lace, candy wrappers and papers of various weights and textures, which are adhered to produce this print (36 x 30 cm.). Oil paint, used as printing ink, easily picks up the textures from the collage.

Lutheran High School.

Collagraphs

In an age of artistic experimentation and a time when combining materials is popular, it was inevitable that a printmaking process would be developed to take advantage of these directions. Collagraphs are prints that are pulled from inked collages. A press is needed for their execution, but, if one is available, this technique offers many possibilities for experimentation.

Glue the desired shapes and textures onto a sturdy plate (one-eighth inch Masonite or olio board, or an acrylic sheet, plywood, Marlite or metal plate of less than one-eighth inch thickness). The plate should be smaller than the size of the press bed, allowing at least a one-inch margin around the completed print.

A wide range of materials can be adhered to make the plate, cloth, lace, textured papers, torn, cut or crumpled papers, found objects that are flat, metal foils, tapes, string, flattened flowers, leaves or aluminum cans, sandpaper, emery cloth and many other items from the workshop or from nature. Arrange the objects and papers and glue them in place with white glue or an acrylic medium. Drips and blobs of glue itself will make impressions on the print.

Another method is to cover an area with acrylic gel or modeling paste. While it is still moist, scratch or texture it as you wish, or press things, such as coins or found objects, into it to create textural images.

When the collage is finished, run the plate through the press with a sheet of wax paper over the surface. This will flatten all the parts and squeeze out any bubbles that might exist.

If the plate is metal or Masonite, file the edge to create a bevel, so that the plate will pass more easily through the press. If you used porous materials, papers, cardboards, laces, leaves, or cloth in the collaging, brush a coat of shellac over the surface. This will allow the textures to remain but will keep the ink from soaking into

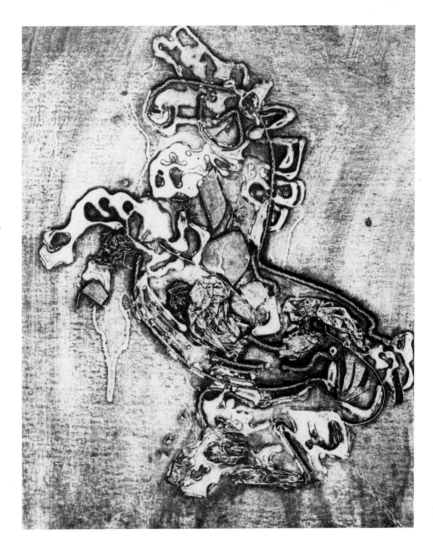

String, crumpled tissue paper, heavy papers and white glue itself are glued and printed to create this rearing horse (36 x 25 cm.). The shading in the negative space is rubbed-on oil paint, used as ink.

Lutheran High School.

143

the surfaces. If you used only non-porous materials (metal, foils, metal tapes, or plastics), this step is not necessary.

When the final plate is dry, it can be inked with a dauber (rolled felt) by rubbing completely over the surface and into the cracks and textures. Etching inks can be used, and it may be desirable to use rubber gloves to keep your hands clean. Once the plate is inked, wipe it with a pad of cheesecloth or tarlatan, depending on the type of print you desire. Some experimentation will help you determine which wiping method is best for your plate and your requirements. A final wiping can be done with sheets or pads of newspaper.

Besides etching ink you can use oil paints or oil based blockprinting ink. Squeeze some ink onto the plate and rub it into the cracks and textures with a soft cloth or a piece of cardboard. Wipe the plate with newspaper and you are ready to print. Cleanup of these oil based inking materials must be done with turpentine or paint thinner.

Etching papers of all types can be tried, or students in the classroom may use heavy drawing paper. Cut the sheets, one inch larger, on all sides, than the plate and soak them in a tray, under a faucet, or with a sponge. The dampened papers can be stored between sheets of blotting paper or with a plastic cover to retain the moisture. The dampening is necessary to allow the paper to conform to the surface of the collaged plate.

Tagboard, papers, string, and glue are used in all three of these collagraphs. The greyed tone which rubbing produces, varies from print to print.

Lutheran High School.

When ready to print, place the inked plate face up on the bed of the press. Center the dampened paper sheet over the plate and lay two heavy felt blankets over the paper. Then run them through the press, which has been adjusted to the proper pressure. While working in a classroom, all students should be using the same thickness for the backing plate. This will eliminate the need to adjust the press for each printing.

When the prints are pulled, they should be laid flat, hung to dry, or taped to a drying board. Experiments can be made with colored inks and overprinting, with various wiping techniques, or with different printing papers. Many artists have developed methods for using collagraph plates for blind embossing or with ink-viscosity printing.

Earth with a purple heart dove soaring to infinity (1976) (56 x 76 cm.) is a collagraph by Stanley E. Lea. Eighteen colors were printed simultaneously, using an ink-viscosity printing method. Some areas were blind-embossed and don't contain any ink.

Introducing other material

8

Although this book deals primarily with paper as a collage material, there are times when other materials might be needed to achieve the desired effects. Found objects, foils, fabrics, wood, metal, plastics and objects from nature, such as flowers, leaves, bark, grass, butterflies, might be included because they are easily available, or because they are more suitable than paper alone. You might find it stimulating to try several of these ideas.

Fabrics

Scraps of cloth will add color and/or texture to some collages. Torn or cut swatches, ribbons, lace, trims, rags, old clothes or new fabrics are some of the materials collage artists explore and use. Course textures will contrast with fine textures. Heavy materials, synthetics, natural fabrics, fibers, string, thread, rope, bleached or dyed fabrics, cheesecloth, burlap, linen, cotton prints and scraps can be used.

Thinned oils and acrylics will create a stained effect and impart a feeling of great age to the work as well as emphasize the natural textures of the fabrics. Fabrics can be used as you find them or they may be tinted or stained with paints before, during, or after the collage process.

Several kinds of fabric were used by Betty B. Schabacker when she created *Cormorants, White Pelican and Saddlebill Stork* (91 x 128 cm.).

Collection of Mr. and Mrs. Boyd Bert.

Paul Souza used collage, casein paint and watercolor to share his impressions of *Morro Bay* (56 x 76 cm.). Notice the three cloth additions. They are the paint rags he used to clean his brushes while working in this location.

White glue and acrylic mediums can be used to adhere the fabrics to a rigid backing board, stretched canvas, or canvasboard. The textures and drips of the glue become part of the collaged surface. It would be a good idea to practice on scraps of cloth, gluing them to backing boards to develop your own adhering techniques. Try flattening the cloth or pushing about the glue-soaked materials to produce ridges and folds. You could also try several coloring mediums to achieve a particular tone.

At some point, you may wish to introduce additional fabric pieces. Do not hesitate to do so. You can estimate how they will look by pinning them to the collage and observing the effect they have on the work.

You can add an enriching patina to the surfaces of your collages by rubbing a thinned oil or acrylic wash over the work with a soft cloth. Allowing the wash to seep into textures and cracks and rubbing it off the higher or more solid relief places will impart a tonal quality to the entire surface. Experiment with patinas of transparent and/or opaque colors to experience several approaches and feelings. Complementary colors or darker values offer the strongest contrasts and most dramatic results.

Ida Ozanoff added gauze to her collage, which also contains rice paper, cardboard and corrugated paper. In *White Bottle* (1966) (76 x 61 cm.), the artist used oil paint in thinned washes to obtain a patina effect on the surface, while allowing the textures of the collaged materials to remain visible.

Collection of Mr. and Mrs. Donald Smith.

Two examples of how cloth can be manipulated in the gluing process are shown by Anne Brigadier. Scraps, including those with frayed edges, can be worked in a number of different ways.

From *Collage: A Complete Guide for Artists*, Watson-Guptill, with permission.

Bettye Saar, in her *Letters from Home Series,* added fabrics to a collage that includes paper, butterflies, flowers and a photo reproduction. All the materials used in *Mash Note (Schoolboy Crush),* (44 x 52 cm.) were glued to an etching which the artist used as a ground.

Courtesy of Monique Knowlton Gallery, New York.

In addition to found papers, flat metal pieces and tissue paper, Paul Souza used several bits of fabric to complete *Quarter Horse Competition* (56 x 76 cm.). The artist also used both watercolor and casein paints to finish the work.

A young child enjoyed working with variously colored, patterned and textured fabric to produce this familiar scene. Does it have an unusual effect on you?

Photo by Jack Selleck.

A

B

C

Clare Ferriter has experimented at length with metal leaf in her collages. She combines various papers with the foils, scratching into or adding over various levels. She uses illustration board or Masonite as a ground for these luminous surfaces. Several techniques and finishes are shown in the three works: (A) *Moon and Cattails* (66 x 51 cm.); (B) *Moon Rising* (30 x 41 cm.); and (C) *Solitude* (66 x 51 cm.).

Foils and metal leaf

The luster and glow of metal can add to your collages. If they enhance the surface and do not attract too much attention to themselves, they can be integrated successfully into your collage. As with cloth, metallic foils or leaf can be used as small areas of contrast, or entire surfaces can be covered and further developed.

Aluminum foils in natural metallic color and printed or colored foils used in wrapping products can easily be found. Aluminum wraps, in various weights, are obtainable at grocery stores, while the commercially colored foils such as gold, blue, red, multicolored, and printed can come from holiday wrapping papers, candy wrappers, food wrappers, or novelty papers purchased in art stores.

White glue and acrylic mediums are suitable for adhering and acrylic and oil paints can be used to color or stain. Metal will resist watercolors, so they will not work in a satisfactory way.

Gold, aluminum, and metal leaf (a combination leaf made of several metals) can be purchased in varying thicknesses to use in collages. Because of their extreme thinness, they can be used on flat surfaces and will conform to the various thicknesses of a heavily collaged surface.

When the leaf surface is still damp, it can be scratched through to reveal the colors underneath. This sgraffito technique can be carried out with a stylus or a sharp pointed tool. Thin rice papers or colored tissue papers glued over foils and leaf, by using an acrylic medium, will allow the sheen of the metal to show through. Heavier rice papers can be used if an opaqueness or heavy translucency is desired. If the metallic look is intriguing to you, you may wish to try new methods using these and other similar materials.

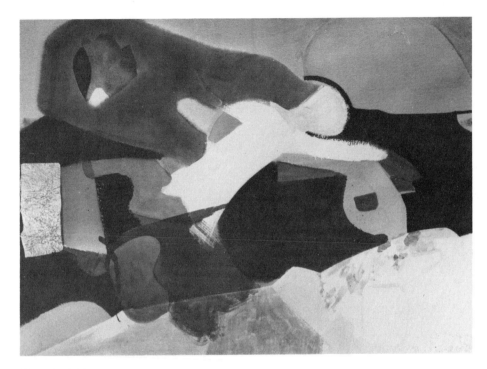

Bits of wrinkled aluminum foil are fun to use in collage work. Paul Souza added a piece, together with corrugated board and Liquitex Gesso, to his watercolor collage, *The Cry* (56 x 76 cm.).

Found objects

It is often stimulating to produce collages that include some found objects in addition to the two-dimensional papers. These collages may emphasize the added three-dimensional materials, or contrast with the flat paper.

Metal machinery parts and various pieces of molded plastic add interest, texture and shape to some collages. Heavier items might need heavier glue or acrylic gels to hold them in place. Stronger adhesives, such as epoxy glues, might also be used. Molded paper, wood, or glass objects can be used because they are of a unique color or shape, but might also be used because of what they are. For example, a plastic knife can be a long, thin, colored shape or it can be a plastic knife in your collage!

Collections of found objects can be used to fill both two-dimensional or three-dimensional spaces since they can be glued on a flat board or arranged in boxes or other containers.

Objects found in a single location (seashore, mountains, desert, cellar, garage) might be permanently arranged to suggest a remembrance of that place. Photographs, drawings, and objects relating to a similar theme can be combined in a single work.

Included in the collages of Pat Tavenner are bits of mirror fragments which reflect the viewer's own image. Can you separate reality from the rest of the collage in *Mirror Montage* (1964) (25 x 33 cm.)?

© Pat Tavenner.

Delphiniums (122 x 168 cm.) is a mixed media collage by Maury Haseltine. It includes rusted metal, iron grating, fabric, paper, and acrylic paint, all adhered to a plywood panel.

Collection of University of Oregon Museum.

A found piece of weathered wood was used as the ground by Tad Miyashita. In *Buzzards Bay* (36 x 51 cm.), he added other found parts, arranging them carefully and simply.

Collection of Lillian Marie Dunn.

Items from nature can be used to create the entire collage or can be combined with paint and/or paper to complete the statement you wish to make. Tree parts (leaves, twigs, bark) can find new life in collages. Flowers, petals, stems and leaves can be used, either the way they are found or pressed flat between the pages of a book or under flat, heavily weighted boards.

String, cord, thread or rope can be used singly as line, or bunched and combined to create textures.

A visit to a stationery or variety store can provide you with a sackful of gummed labels of all sizes, shapes and colors. Do they suggest any collage uses to you? Gummed labels and decals, printed with words, designs or school mascots might suggest still more collage possibilities.

Look around you in museums, galleries and art magazines to see what objects contemporary artists are gluing together to produce both two- and three-dimensional work. Perhaps their experimentation will open new doors for your own creative expression with collage.

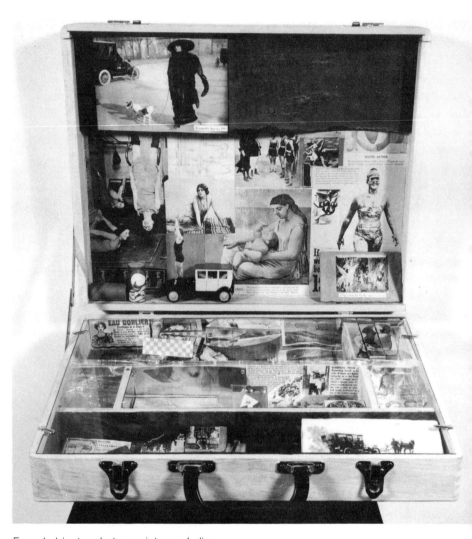

Found objects, photos, prints, and clippings were combined and arranged by E. M. Plunkett in a wooden case. The entire work is titled, *How to Understand Picasso.*

Courtesy of Byron Gallery, Inc., New York.

Things found in nature (leaves and flowers) were combined with things found in old bookstores (letters, stamps, pieces from parts of books) by Nicholas Follansbee. This untitled collage is probably the smallest (8.7 x 13 cm.) shown in this book.

The flower-covered floats in Pasadena's Rose Parade are really huge (about 19 meters long) collages. This illustration is a detail of a large mural, in which flower petals, whole flowers, seeds, and bark are glued to a ground.

Courtesy of C. E. Bent and Sons Float Builders, Pasadena.

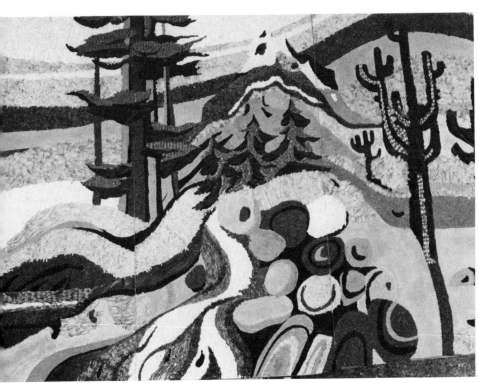

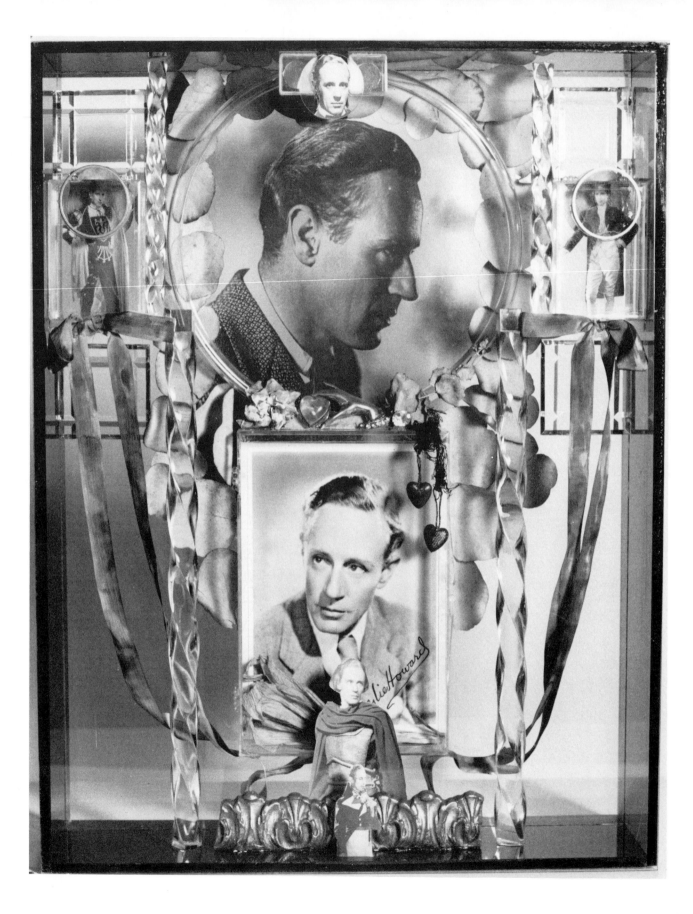

Leslie Howard (51 x 41 x 10 cm.) is a
three-dimensional collage,combining var-
ious found objects and photographs.
Sabato Fiorello affixed many of these
pieces to sheets of clear acrylic at various
depths and mounted the entire work in an
acrylic case.

Courtesy of Orlando Gallery, Encino, California.

A student mixed reality with illusion in
a collage that includes a plastic knife,
magazine illustration and watercolor
painting.

Emerson Junior High School.

Decals that center on a theme of motor-
cycle racing were put together and com-
bined with passages of colored tissue
paper by an elementary school student.

Collection of Mr. and Mrs. Jack Ledbetter.

Other ideas

9

One of the most fascinating aspects of working with collage is that there are few rules or limits, set either by the artists or by the materials. This freedom allows for continual exploration and experimentation. While you are working on one collage with one set of papers or materials, the process could suggest ideas for your next work. You may be stimulated by new ways to combine old materials, or new ways to arrange the materials at hand.

Instead of tearing all the papers that you use, try cutting them into square shapes and putting your work together in a mosaic-like arrangement.

Spend several days experimenting with crayon and watercolor combinations, for example. Compile a large number of interesting swatches on different papers. Cut the swatches to a variety of sizes and shapes, selecting those parts of the experiments that appeal to you. Layout the pieces on a contrasting surface, such as black railroad board or poster paper. When you have an acceptable arrangement, glue them in place. Study some magazine layouts to help you place the swatches in an interesting way.

Colored tissue paper will leave stain marks when wet and applied to papers with light values. Try wetting sheets of tissue with water or thinned with glue; press them into place and then lift the papers. The resulting stained areas might suggest landscape features on which you can paint, glue, or leave as is. Or, the stained papers might be torn up and used as prepared papers in later collages.

Mosaic-like designs, using square-cut pieces of magazine colors or other colored papers, are details often found in collages. This detail photograph is part of a larger collage in which the pieces were about one centimeter square.

Lutheran High School.

Stains, made by "printing" with wet and colored tissue papers, produce fascinating textures. They can be used as is, or become the ground for further painting, printing or collage.

Gardena High School.

These swatches are parts of the crayon and watercolor experiments of one student, mounted on a sheet of black poster board. Only the most interesting parts of many experimental swatches were used in the designed arrangement.

A

B

C

D

If you cut one magazine photograph (or page of type) into strips, you can use the strips in a variety of ways: A) leave a space between the strips (you can vary the sizes of spaces for various effects); B) stagger the strips — one up, one down, etc.; C) invert every other strip; D) and alternate them as follows, 1, 13, 2, 12, 3, 11, etc., or according to some other pattern. Try these ideas on a photograph of a face, animal, figure, or automobile.

Rearranging a single sheet of paper

There are many ways to create interesting designs by cutting single sheets of paper and arranging the parts in collage form. Some of these illustrations might be good ways to get into the methods and ideas of collage. The examples on these pages will produce different effects if plain papers are used in contrasting, subtle or related hues. Different photographic subjects will also produce new images. Think what can be done with circles, triangles, squares or ovals.

Scissors, razor blades, stencil knives, or X-acto knives can be used for cutting, using a heavy cardboard surface for a cutting board. Paper clips can be used to hold papers together for some of the problems. You can produce a great variety of collages by using single sheets of paper and some imagination, or experiment with various papers and different colors.

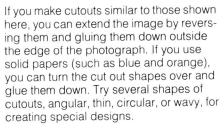

If you make cutouts similar to those shown here, you can extend the image by reversing them and gluing them down outside the edge of the photograph. If you use solid papers (such as blue and orange), you can turn the cut out shapes over and glue them down. Try several shapes of cutouts, angular, thin, circular, or wavy, for creating special designs.

These collages are made by placing one photo image on top of another and cutting vertical strips through both of them at the same time. Adhere each picture by using alternating strips from the two photographs. Try using athletes in action, automobiles, crowds of people, animals, or figures for a similar set of collages.

A single page can be extended by making multiple cuts with scissors or a sharp cutting blade. Place each cut part slightly farther from the center to develop interesting arrangements. This idea will work well also using solid colors.

These two collages were made by cutting organic, free-flowing shapes from two photo images placed one over the other. Try using three images, consisting of one photo image, tissue paper and a page of magazine type. You may also try to cut the design of an animal through three papers and adhere the cutout parts in a new arrangement.

Paper and pattern

Pattern is the principle of design that relies on repeated elements or motifs to fill the surface. The problems on these pages are really three-dimensional paper collages. In each case, a module or design unit is produced first. It might be a flat triangle, a circle or a more complicated unit. Many of these are made and then are arranged to cover a backing surface. A regular arrangement will produce a planned pattern. An irregular arrangement will result in a random pattern.

If these patterned surfaces are placed in a strong light, sunlight, for example, and rotated, their shadows will help establish intricate patterns which will change with each slight rotation.

Delicate and complicated units (based on circles in squares) are placed at various depths in the squares. The light, playing over the entire surface, creates many interesting value contrasts.

Modules shaped like figure 8's are arranged and glued to illustration board to create a planned pattern that becomes more intricate in the sunlight.

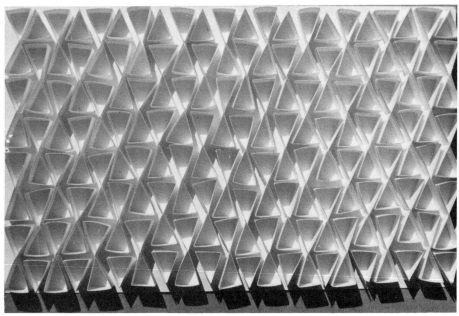

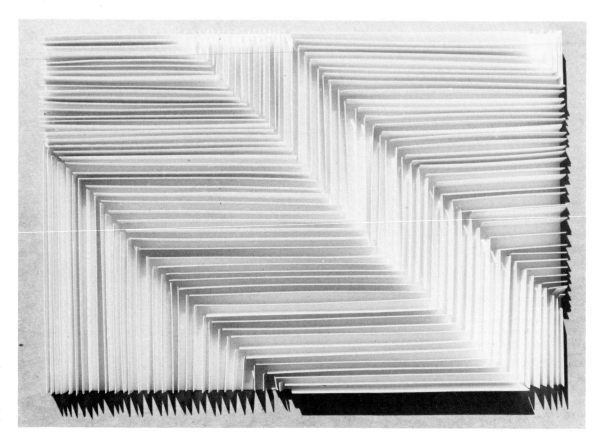

Scored paper is creased into fan-like
folds, producing an interesting pattern in
the light.

Cylinders of varying lengths create a ran-
dom pattern as light falls across the sur-
face of the arrangement.

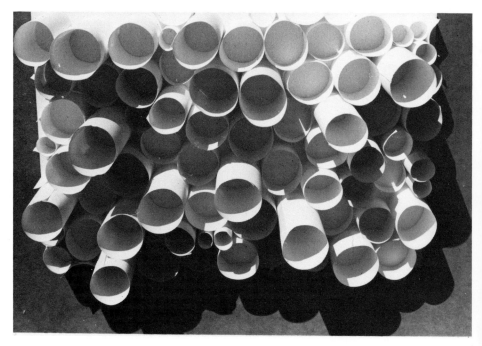

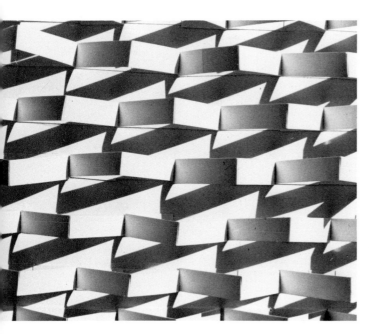

One arrangement, made from flattened triangles, produces vastly different patterns as sunlight strikes it from different angles.

All patterns on these pages are from Lutheran Junior High School.

A student glued bits of colored cloth on a
burlap-covered cardboard mask to add
splashes of color and decoration.

This entire octopus is a three-dimensional
collage, including the pasted tentacles
and the decorations.

A papier maché pig has bits of colored
tissue paper, tempera paint and wool
string adhered for decoration.

Bits of patterned fabric are being glued to the surface of this papier maché animal. White glue is the adhesive used in this patchwork arrangement.

Collage and sculpture

All the examples we have seen in the book have been carried out on flat grounds, such as Masonite, plywood, cardboard, illustration board, or heavy paper.

Some paper materials (like tissue papers, paper napkins, newsprint, and crepe paper) are thin and flexible enough, especially when wet with glue or paste, to fit onto three-dimensional surfaces. Fabrics also might be used in this way, if they are supple enough.

Existing forms, such as jars, pots, waste baskets, lamp shades, rocks, and cans, can be collaged with a variety of materials. Papier maché sculptures can also be decorated with collaged surfaces. Tissue papers and crepe papers are excellent materials, as are certain types of fabrics, for use as surface decorations. White glue or acrylic mediums work well on such projects, and even thick, clear lacquer works well with tissue papers.

You might use these materials to work on relief sculptures that will go on walls or on collages that have high relief areas. It may take a bit of trial and error to find the correct adhesives for certain surfaces. Perhaps some of the items on these pages will help get you started on still another way of working with paper collage.

Glossary

Collagists work with a wide variety of materials and techniques and have a vocabulary of their own. Many of these terms are French, since artists from that country were instrumental in the development of collage techniques. Most words used in the text are explained immediately in their context; however, in your outside reading, you might come across some of the following terms.

Adhesives the glues or pastes used to stick papers to the support or backing.

Assemblage the process of collecting and assembling materials to fix in a completed design. Elements can be glued, welded, or nailed, depending on their character. Work may vary from relief surface to full three-dimensional form.

Brûlage scorching or charring the edges of paper or cloth bits by passing them over a candle flame.

Collage pasting pieces of paper to a surface to create a visual statement. The process can be used alone or combined with other media (paint, drawing, printmaking).

Collagraph a print pulled from an inked surface (plate) which has been made of various materials glued together.

Combine paintings paintings which use collaged pictures as part of the surface imagery, yet remains painterly in their feeling.

Combine prints a type of monoprint which produces a printed image from a group of low relief items. An inked brayer is often run over a sheet of thin paper laid over the objects.

Dada an art movement (flourishing in Europe from 1915–1923, stressing the cult of anti-art) which made wide use of collage techniques.

Déchirage using torn papers (ragged edges) to create the collaged design. The term may refer to gluing down torn papers and also to retearing collaged surfaces.

Décollage the process of tearing away portions of a glued collage. Good examples of found décollage would be partially obliterated billboards.

Découpage cutting and gluing paper shapes, using only crisp, hard edges.

Fabric collage gluing textiles or fabrics to a support or board, cardboard, or other fabric to create textured designs.

Fixing the process of brushing or spraying an acrylic medium over the completed collage surface to strengthen and protect it.

Found collage surfaces (such as billboards, walls, etc.) that have had pasted images put on them, but may be partially obliterated.

Froissage wrinkling, creasing, and ribbing the surfaces of papers as they are being glued down, to produce linear movement on the surface.

Frottage taking rubbings from surface textures and tearing them up to use in collages. Any materials (wax crayon, conte crayon, pencil) may be used.

Fumage toning or coloring paper pieces by passing them through the smoke from a candle. The carbon deposits act as the toning agent.

Ground the surface on which the collage materials will be glued (cardboard, Masonite, heavy paper, etc.)

Mixed media collage combining other techniques, such as acrylic painting or pencil drawing, with paper collages.

Natural collage surfaces in nature (walls, rocks, trees, sidewalks) that exhibit collage-like effects, though always unintentional.

Paper assemblage using various paper items to create a three-dimensional surface. Work may range from a shallow relief surface to a fully developed three-dimensional sculpture.

Paper mosaic using similarly-sized, cut paper pieces (for example, half-inch squares) to create the entire design.

Papier collé the French term for the process of pasting papers. It is the term from which the word *collage* originated.

Photomontage actually the term refers to a photographic darkroom technique, but when working with collage, it often refers to a design produced by gluing photo images to a backing to create new statements.

Primer usually a white paint (such as gesso or white latex house paint) that is used to cover a porous or dark surface (such as Masonite) to enhance the gluing process and allow for brighter colors.

Rice papers the Oriental, handmade papers (usually from Japan) which come in a wide range of textures, weights, and colors.

Silhouettes cutting paper shapes to conform to the outside contours of forms.

Support the surface to which collaged materials are glued (such as cardboard, Masonite, etc.).

Veiling using semi-opaque or translucent papers to partially obscure images underneath.

One of the leaders in the revival of collage as a contemporary art form was Robert Rauschenberg, who used a wide variety of found objects in his "combine paintings." *First Landing Jump* (1961) (228.5 x 207 cm) includes a tire, khaki shirt, license plate, leather straps, mirror, iron street light reflector, live blue light bulb, electric cable, steel spring, tin cans, various pieces of cloth and oil paint on composition board.

The Museum of Modern Art, New York. Gift of Philip Johnson.

Selected Bibliography

These books may present further examples of paper collage and often emphasize other related materials. If you become interested in a special phase of collage, one or more of the books listed can provide you with additional information.

Ballarian, Anna, *Fabric Collage*. Davis Publications, Inc., Worcester, Massachusetts, 1976

Bellofatto, Roberta, *Collage with Crepe Paper*. Dennison Manufacturing Company, Framingham, Massachusetts, 1969.

Brigadier, Anne, *Collage: A Complete Guide for Artists*. Watson-Guptill Publications, New York, 1972.

Brow, Francis, *Collage*. Pitman Publishing Corporation, New York, 1963.

Capon, Robin, *Paper Collage*. Charles T. Branford Company, Newton, Massachusetts, 1975.

Conner, Margaret, *Introducing Fabric Collage*. Watson-Guptill Publications, New York, 1969.

Haley, Ivy, *Creative Collage*. Charles T. Branford Company, Newton, Massachusetts, 1971.

Hutton, Helen, *The Techniques of Collage*. Watson-Guptill Publications, New York, 1972.

Jarvis, Harriet and Rudi Blesh, *Collage: Personalities, Concepts, Techniques*. Pitman Company, London and New York.

Meilach, Dona Z. and Elvie Ten Hoor, *Collage and Assemblage: Trends and Techniques*. Crown Publishers, Inc., New York, 1973.

Seitz, William C., *The Art of Assemblage*. The Museum of Modern Art, New York, 1968.

Simms, Caryl and Gordon, *Introducing Seed Collage*. Watson-Guptill Publications, New York, 1971.

Stephan, Barbara B., *Creating with Tissue Paper*. Crown Publishers, Inc., New York, 1973.

Stevens, Harold, *Transfer: Designs, Textures and Images*. Davis Publications, Inc., Worcester, Massachusetts, 1974.

Stoltenberg, Donald, *Collagraph Printmaking*. Davis Publications, Inc., Worcester, Massachusetts, 1975.

Vanderbilt, Gloria, *Gloria Vanderbilt Book of Collage*. Van Nostrand Reinhold Company, New York, 1970.

Wolfram, Eddie, *History of Collage*. MacMillan Publishing Company, Inc., New York, 1975.

Index

Acknowledgments

In putting this book together, it was my desire to show a wide variety of collage expression. So that a cross section of American collage activity could be presented, collage artists from across the country were contacted. Nearly a hundred of them were happy to share their work and sent examples to be included. Their response was so generous that there is room in the book for only about twenty percent of the material sent. The examples chosen illustrate points made in the text, and all are used with the permission of the artists.

To help you see the geographic distribution of these generous artists, they are listed by the states in which they currently live and work. I thank them all sincerely for their help and consideration, only wishing that we could have shown more.

ARIZONA: Chuck Winter; CALIFORNIA: Richard Adkins, Jim Bolin, Pauline Eaton, Marie Fillius, Sabato Fiorello, Nicholas Follansbee, Ruth Gewalt, Verily Hammons, Corrine West Hartley, Rick Herold, Caroline Kent, George Ketterl, Don Lagerberg, Jack Ledbetter, Mathilde Lombard, Arthur Matula, Alexander Nepote, Perry Owen, Bettye Saar, Arthur Secunda, Stephen Seemayer, Jack Selleck, Paul Souza, Marjorie Stevens, Joan E. Tanner, Pat Tavenner, Joyce Treiman, Gordon Wagner, Barbara Weldon; CANADA: P. Mansaram; COLORADO: Carole Barnes, Ann-Marie Kuczun; CONNECTICUT: Ilse Getz, Ethel Margolies; FLORIDA: Lois Bartlett Tracy; HAWAII: Barbara Engle, John I. Kjargaard; ILLINOIS: Ronald Ahlstrom, Howard B. Anderson, R. C. Benda, Edward Betts, Glenn Bradshaw; MASSACHUSETTS: Michaelina Aylward; MISSOURI: James Varner Parker; NEBRASKA: Reinhold Marxhausen, Richard Wiegmann, William Wolfram; NEW JERSEY: Kuni Strange, Amy West; NEW YORK: Banerjee, Hennelore Baron, Romare Bearden, Anne Brigadier, Walter Davis, Margo Hoff, Si Lewen, Tad Miyashita, Ida Ozanoff, E. S. Pearlman, E. M. Plunkett, Gloria Rosenthal, Rubi Roth, Judith Rothchild, Kathleen Zimmerman, Murray Zucker; PENNSYLVANIA: Shirley Moskowitz, Betty B. Schabacker; TEXAS: Stanley E. Lea, Helen van Buren, Roger Winter; WASHINGTON: Maury Haseltine; WASHINGTON, D.C.: Clare Ferriter.

Art teachers and their students also contributed to the visual presentation in the book. First let me thank my own students, who have contributed to many of my books. Also to Jim Burke at John Marshall High School in Los Angeles; Laura De Wyngaert at Thorne Junior High School in Fort Monmouth, New Jersey; Grace Garcia at Hollywood High School, California; George Horn of the Baltimore Public Schools, Maryland; Helen Luitjens at Paul Revere Junior High School, Los Angeles; Thomas Nielsen at Nightingale Junior High School, Los Angeles; Jack Selleck at Emerson Junior High School, Los Angeles; Roland Sylwester at Lutheran High School, Los Angeles; and Ted Wessinger at Gardena High School, California.

Galleries also helped by supplying numerous visual materials, including Challis Galleries, Laguna Beach, California; Chuck Winter Gallery, Tucson, Arizona; Fireside Gallery, Carmel, California; Spencer's Galleries, Pasadena, California; and an especially large thank you to Bob Gino and Phil Orlando at Orlando Gallery in Encino, California. Their help has (as always) been tremendous.

Historically important works in the collections of major museums are necessary to set the scene for today's collage activity. For assistance in obtaining photographs from museum collections, my thanks to: Philippa Calnan at the Los Angeles County Museum of Art; Micki Carpenter at the Museum of Modern Art in New York; Sanna Deutsch at the Honolulu Academy of Art in Hawaii; Dorothy Hanbury at the Philadelphia Museum of Art; Carol Simons at the William Rockhill Nelson Gallery of Art, Kansas City; and the Curator of the Tate Gallery in London.

A word of thanks also to Roberta G. Rankin at Dennison Manufacturing Company for help with the section on crepe paper and collage.

Special thanks to fellow teachers who have kept encouraging me on this project; to Davis Publications for waiting patiently for the manuscript to get done; and to my wife, Georgia, who has to put up with some weird hours and circumstances at times . . . all for the sake of collage.

GFB

176